Nothing survived, of course, from the ground as it t
in 1814 – the third and last of the grounds he was to ,
those heavy-gambling aristocrats who formed the core t
building was now the Tavern, there on our left, taking us back to the late 1800s when a tall and
dynamic young man called W. G. Grace was catching everyone's eye. Several of the stands, by
contrast, had been built comparatively recently, in the interwar years, the work of an architect
fêted around the British Empire, Sir Herbert Baker. We could not have imagined that they
would be almost all swept away in our lifetime: the cantilevered 'free' stands behind us; the
Mound Stand to our left; and the well-proportioned Grand Stand on our right with its dark
red roofs, its central scoreboard, and a weathervane in the form of Old Father Time perched
dramatically on top. Only the undemonstrative little Q stand, to the left of the Pavilion, would
live on into the next century.

Wally Hammond was soon leading out the English team, and, to our considerable delight,
Indian wickets started falling with some regularity, the burly Alec Bedser taking seven of them,
extracting considerable lift from his short, ambling run to the excited approval of a cluster of
close fielders. Before the afternoon was over, India had been bowled out for 200.

We bore Len Hutton's early dismissal with fortitude, for it brought in Denis Compton.
There he was, our cigarette card hero, England's great hope for the future, striding in to
massive applause, continuing at twenty-eight the promising Test career interrupted by war.
We knew all about that promise. 'In two seasons Denis Compton has come right to the front
as a stylish right-handed batsman,' declared *Cricketers of 1938*. 'When eighteen he scored 1,004
runs, averaging 34.62 and next year headed the Middlesex batting, his full aggregate being
1,980, average 47.14. His highest innings was 177 at Lord's...' The thrilling possibility of seeing
Denis Compton bat had quite overshadowed any thoughts about the difficulties of the wicket
– uncovered and soaked overnight, but now drying out fast – and bitter indeed was the shock
when our hero was bowled for a golden duck. Wally Hammond, a stocky figure well into his
forties, bustled out confidently, however, and cheered us all up by dispatching his first ball for
4 with a copybook cover-drive. He was clearly a big favourite with the crowd, and there was
something positively Churchillian about the way he counter-attacked so pugnaciously. Though
both he and Cyril Washbrook fell before the close, the fair-haired Joe Hardstaff brought style
to the end of our day, his innings on the Monday blossoming into a match-turning double
century.

It had been a memorable occasion, the glamour enhanced by the saris worn by Indian ladies
among the throng of spectators parading on the outfield in the intervals, a hint of exotic lands
across distant oceans, strangely different from anything yet seen by two young boys from the
London suburbs. And though our admired Denis had on this occasion disappointed, Lord's itself
had certainly cast its spell upon us.

Next year, in that legendary Edrich-Compton run-harvest in the summer of 1947, my brother
and I returned regularly, usually bringing with us a lunch of tomato and egg sandwiches (a real
post-war luxury) and fizzy Tizer and sitting in the upper tier of 'the free seats' where we would
note down each and every ball with scholarly precision in our scorebooks. These little books
which we filled up with the runs of Compton, Edrich and that fine Middlesex opening pair, Jack

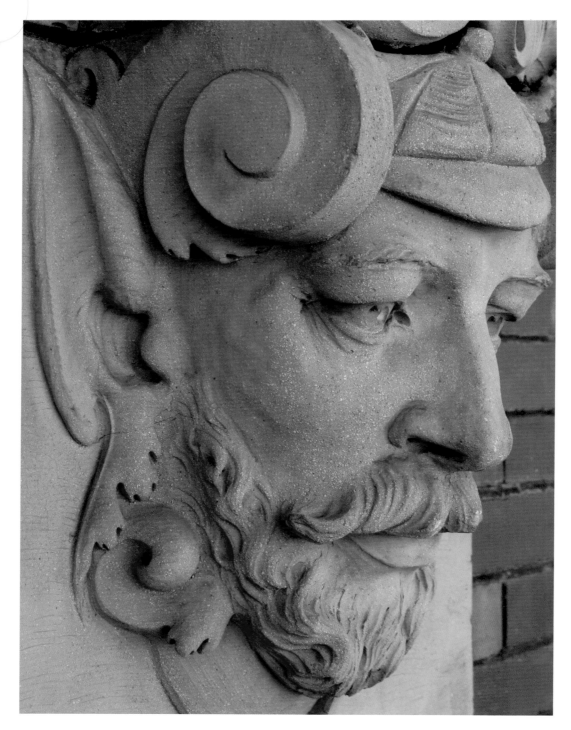

The Patriarch
A terracotta gargoyle thought to represent Lord Harris.

6

LORD'S
THROUGH TIME
Anthony Meredith

AMBERLEY PUBLISHING

Remembering Charles Thomas Meredith, CBE, for whom Lord's always meant Hearne and Hendren

First published 2012

Amberley Publishing
The Hill, Stroud
Gloucestershire, GL5 4EP

www.amberley-books.com

Copyright © Anthony Meredith, 2012

The right of Anthony Meredith to be identified as the Author of this work has been asserted in accordance with the Copyrights, Designs and Patents Act 1988.

ISBN 978 1 4456 0637 8

British Library Cataloguing in Publication Data.
A catalogue record for this book is available from the British Library.

Typeset in 9.5pt on 12pt Celeste.
Typesetting by Amberley Publishing.
Printed in the UK.

Introduction

My father loved Lord's. When, in 1946, the Indians arrived for the first official Test there since the war, he eagerly took a Saturday off work to share its pleasures with his two young sons. We could hardly believe our good fortune. Cricket was our passion, and we knew all about the unique position of Lord's as the historic home of Marylebone Cricket Club, whose responsibility was to run the whole game. We knew, too, of its importance as the home of Middlesex, in general, and Denis Compton, in particular. But, above all, Lord's resonated with the echoes of great Test Matches of the past, before the war had put a stop to them. As the proud possessors of that most popular of cigarette card sets, Players' *Cricketers of 1938*, we were already brimful with knowledge of the early careers of all the current England heroes.

Anticipation mounted as we emerged from the Bakerloo Line at St John's Wood and joined the throngs sweeping cheerfully down Wellington Road as if in some glorious celebratory pageant. Smiles faded a little as we came across a queue unwinding itself along the ground's boundary wall, and it was in some anxiety that we eventually joined its tail. Would the gates be closed before we reached the turnstiles? Exclusion seemed a real possibility as we began to shuffle forwards, dreaming of the mysteries within and marvelling at the numbers of those arriving after us. Father remained optimistic. Queuing for admission, he assured us, had been the norm before the war, when crowds flocked to the ground to see Middlesex's great stars Jack Hearne and Patsy Hendren.

Our anxieties must have lasted an hour or two, but they vanished at one push of the turnstiles and the quick dash forwards for that arresting first sight of the Nursery Ground. There was little time to take it all in, for we had fresh challenges to meet: the purchase of a scorecard; the hiring of a shiny green-red cushion; and the all-important search for somewhere to sit, which was not going to be easy. The gates were shortly to be shut with over 30,000 inside, and all 'the free seats' at the Nursery End had already gone, but there were still a few spaces on the damp grass around the boundary – it had been raining heavily overnight – and we were soon happily staking our claim. How fortunate to be in only the fourth or fifth row! And there, in front of us, we could see (more or less) the wickets, pitched and ready for play, with that majestic Pavilion behind, hugely impressive in its red brick solemnity and (though not yet sixty years old) seemingly as ancient as Time itself.

2d. Lord's Ground

ENGLAND v. INDIA

SAT., MON. & TUES., JUNE 22, 24, 25, 1946. (3-day Match)

INDIA	First Innings		Second Innings
1 V. M. Merchant	c Gibb, b Bedser	12	
8 V. Mankad	b Wright	14	
4 L. Amarnath	l b w, b Bedser	0	
7 V. S. Hazare	b Bedser	31	
3 R. S. Modi	not out	57	
†5 The Nawab of Pataudi	c Ikin, b Bedser	9	
6 Gul Mahomed	b Wright	1	
15 Abdul Hafeez	b Bowes	43	
*9 D. D. Hindlekar	l b w, b Bedser	3	
12 C. S. Nayudu	st Gibb, b Bedser	4	
11 S. G. Shinde	b Bedser	10	
	B 10, l-b 6, w , n-b ,	16	B , l-b , w , n-b
	Total	200	Total

FALL OF THE WICKETS

1—15	2—15	3—44	4—74	5—86	6—87	7—144	8—147	9—157	10—200
1—	2—	3—	4—	5—	6—	7—	8—	9—	10—

ANALYSIS OF BOWLING

Name	1st Innings						2nd Innings					
	O.	M.	R.	W.	Wd.	N-b.	O.	M.	R.	W.	Wd.	N-b
Bowes	25	7	64	1
Bedser	29.1	11	49	7
Smailes	5	1	18	0
Wright	17	4	53	2

ENGLAND	First Innings		Second Innings
1 L. Hutton	c Nayudu, b Armanath	7	
2 C. Washbrook	c Mankad, b Armanath	27	24
3 D. Compton	b Armanath	0	
†4 W. R. Hammond	b Armanath	33	
5 J. Hardstaff	not out	205	
*7 P. A. Gibb		60	
6 J. Ikin		16	
8 T. F. Smailes		?	
9 A. V. Bedser		30	
10 D. V. P. Wright			
11 W. Bowes			
	B , l-b , w , n-b ,		B , l-b , w , n-b
	Total	428	Total

FALL OF THE WICKETS

1—16	2—16	3—61	4—70	5—	6—	7—	8—	9—	10—
1—	2—	3—	4—	5—	6—	7—	8—	9—	10—

ANALYSIS OF BOWLING

Name	1st Innings						2nd Innings					
	O.	M.	R.	W.	Wd.	N-b.	O.	M.	R.	W.	Wd.	N-b

Umpires—Smart & Baldwin †Captain *Wicket keeper Scorers—Mavins & Ferguson
The figures on the scoring board indicate the batsmen who are in
Play begins at 11.30 1st day, 2nd & 3rd days at 11 Stumps drawn at 6.30 each day.
Spectators are requested not to move from their seats during the progress of an over

INDIA WON THE TOSS

England won by 10 wkts

4

Robertson and Sydney Brown, all came from the Lord's bookstall, which, siren-like, drew us into its attractive clutches most lunch and tea intervals. It has long since vanished, but memory suggests it was a permanent, circular structure, nestling between the Mound Stand and the Tavern, its precious wares laid out enticingly, all way round, on deep counters. In the 1920s and 1930s (in collaboration with a similar bookstall at The Oval) it had published its own postcards and booklets, and there were still postcards for sale in the early post-war years within pocket-money range. Just occasionally we made a big acquisition – perhaps one of those 'Know Your County' booklets or a brochure celebrating the year's tourists. There was little merchandising to augment the written word in those days, but the bookstall was still as alluring as an Aladdin's cave.

We quickly grew to know and love every feature of the ground. We were duly awed by the Pavilion, that dramatic creation of Thomas Verity, an architect whose skill with terracotta had helped embellish several of the fine London theatres with which he had made his reputation. The creation of this new Pavilion in the winter of 1889–90 had been inspired by the need to celebrate the MCC Centenary (1787–1887) in appropriate style and proved a turning-point in the ground's long saga, for its impressive proportions and architectural magnificence, outstripping every other pavilion in the land, at one stroke consolidated for Lord's its position of national dominance. My brother and I, as we lurked at the back of the Pavilion by the members' entrances, autograph books in hand and eyes alert for figures in white flannels, were certainly aware that here was the very heart of English cricket. There was an air of bustle and authority all around, and, as we watched the members hurrying through the doors and up the stairs which led to the Long Room, we could have been outside the Senate House in ancient Rome, thronged with the toga-clad ruling classes.

We probably missed the full significance of the Harris Memorial Garden, close by the Pavilion, though of course we would surely have admired the inscribed tablet which we had seen in the background of many team photographs, telling us of George Robert Canning, the 4th Baron Harris, 'a great cricketer, a great gentleman and a wise counsellor'. Harris, we learnt, had played for Eton, Oxford and Kent and captained England in 1884 when Lord's hosted its first Test Match. His activities as a 'great gentleman and wise counsellor' were less widely known. Harris had dominated MCC's inner sanctum for fifty years, one of the key figures in a long line of dominant amateurs, from George, 9th Earl of Winchilsea, to Sir Pelham 'Plum' Warner and Sir George 'Gubby' Allen, powerful patriarchs who resolutely moulded Lord's their way, making it synonymous with high privilege and accomplishment. Harris, too, had played his part in investing cricket with an uplifting moral tone, famously declaring in 1930 that it was 'more free from anything sordid, anything dishonourable than any game in the world'. To play it 'keenly, honourably, generously and self-sacrificingly' was 'a moral lesson in itself'. The best classroom of all was 'God's air and sunshine'.

With such ideals being strongly promoted, the second-class position of the professionals within the game was something of an anomaly. At Lord's in 1890, for example, the professionals were barred from the new Pavilion and confined to a small building alongside. The inequalities of the English class system had, of course, long been ritualised at Lord's in the annual clash between the all-amateur Gentlemen and the all-professional Players, a fixture dating back

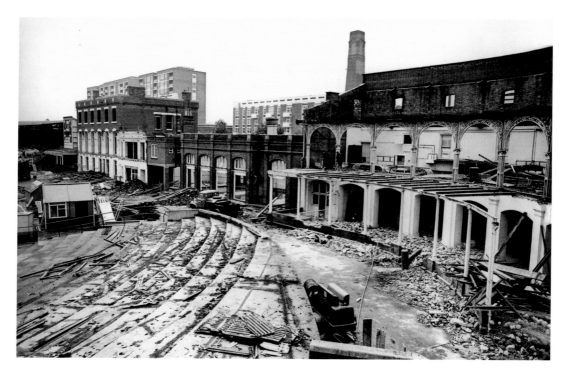

The March of Time
The demolition of the Tavern complex in 1966, and its replacement, the Tavern Stand (during a Test Match in 1995). Inset (*left to right*): a corner of the Tavern Hotel (1868); O Block with refreshment rooms (1881); P Block, with refreshment room and boxes, and the adjacent clock tower (1900).

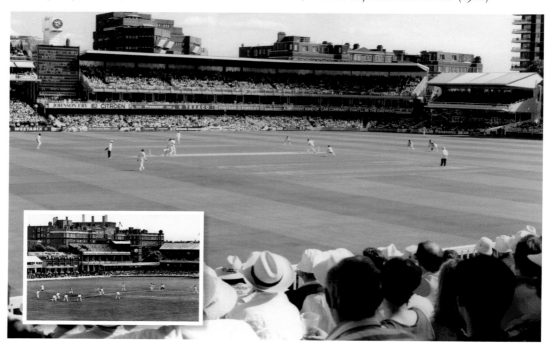

to 1806. By the time my brother and I were watching it, social changes were beginning to undermine the match's validity, but it served as a useful Test trial, and, along with two other historic fixtures – Oxford v Cambridge and Eton v Harrow – was still articulating the Lord's ethos of exclusivity. We certainly took the fixture very seriously, enthusiastically supporting the Gentlemen even though our idol was a Player, Compton D. C. S. (Only the amateurs were allowed their initials before their names on most county scorecards.)

Some years later, in 1970, on becoming a member of MCC, I was able to enjoy Lord's from a new perspective, the Gentlemen's former stronghold, often watching from the Pavilion's first balcony in the company of those splendid terracotta gargoyles of Lord Harris and his fellow MCC committee members of the late 1880s. It was exciting to be able to participate in voting at Annual General Meetings on a series of important issues, for the winds of change were by now blowing (and sometimes positively howling) around St John's Wood. The '60s had already brought significant alterations. The amateur-professional distinction had finally been abolished. The one-day game had been introduced (the Gillette Cup in 1963 being the inspiration for a World Cup twelve years later). And MCC's control of the country's cricket had been ended with the creation of a Test and County Cricket Board and an English Cricket Association.

The 1970s revealed an increasing discrepancy between the ground's international pre-eminence and its ageing facilities, but the needed redevelopment would not come easily. The only two arrivals since that Indian Test Match of 1946, the new Warner and Tavern stands, had both met considerable resistance from the membership. The loss in the 1960s of the ground's most historic feature, the line of Victorian buildings between the Tavern and Clock Tower, which included charming wrought-iron balustrades and boxes that royalty had once patronised, had been exacerbated by the erection of a twelve-storey block of flats in the south-west corner of the ground. Many resignations had followed this victory of pragmatism over aesthetics.

In the early years of my membership, therefore, the club was struggling to come to terms with its needs. Unexpected costs had bedevilled the new Tavern Stand, moreover, leaving the strained finances as a useful excuse for those favouring the status quo. There were other diversions, too, with MCC involved in the ramifications of both the D'Oliveira Affair and the Kerry Packer revolution. So the physical development of Lord's remained dormant.

The cricket, by contrast, was more vivid and entertaining than ever, with popular one-day matches some compensation for the smaller attendances at championship games. Lord's continued to host the big occasions well, adapting itself surprisingly easily to accommodate a succession of noisy and exciting one-day finals, and such was its prestige that when, in 1980, the centenary of England's first home Test Match against Australia was commemorated, Lord's provided the venue, though 100 years earlier The Oval had done so. The Lord's Tests, then as now, seemed to bring out the absolute best from our visitors, and there was no such thing anymore as an 'easy' Test series, as the assured performance of Sri Lanka in their inaugural Test exemplified in 1984. So many great players graced the Lord's stage in the '70s and '80s that it would be invidious to single out centuries by Kanhai, Sobers and Richards as my three most

Sympathetic Modernity
The new Mound Stand of 1987 contrived to retain much period atmosphere by taking one of the aspirations of its late Victorian predecessor (a curving row of supporting brick arches) as a starting-point. Above, the modern superstructure rises from three such arches. Below, to the right, a row of pseudo-Victorian arches copying the few which were built in 1899; to the left, a brick wall of long pedigree.

cherished innings, and, anyway, no innings could fully eclipse Greg Chappell's elegant century in Massie's match of 1972, so commandingly correct and resourceful. And then there were those thrilling fast-bowling partnerships like Lillee and Thomson and Roberts and Holding. Will there ever again be such heavy a sense of menace enveloping the ground as that morning in 1975 when Dennis Lillee came in from his distant mark at the Pavilion end, stride lengthening, speed increasing, elbows pumping and nostrils flaring with the strong scent of early English wickets?

Perhaps the constant high quality of the big matches served to mask the ground's inadequacies. Certainly without private benefactions those inadequacies would have remained unaddressed in that era. But a much-needed indoor cricket school, opened by Gubby Allen in 1977, was generously supported by Sir Jack Hayward, and John Paul Getty Jnr (having assimilated a deep passion for the game via his good friend Gubby Allen) largely funded the £4.8 million required for a modern Mound Stand, opened in MCC's Bicentenary year of 1987. Just as the centenary of 1887 had prompted a key new building, so too the bicentenary, for the Mound Stand, with its much-acclaimed tented roof and splendid blend of commercial practicality and visual elegance, was so inspiring that it brought a new ambition to the old ground: perhaps Lord's had a future as a showpiece of modern architecture?

In the meantime one of the smaller improvements of the 1980s, the opening of a splendidly enlarged MCC Library in the tennis court block at the back of the Pavilion, was a particular bonus for those engaged on cricket history. My own researches in due course led to an interview with Gubby Allen, the last of the great Lord's patriarchs, to discuss the MCC post-Bodyline tour of Australia of 1936–37 which he had skippered. Allen, at eighty-seven, was still living in the lovely house he rented from MCC in Grove End Road, backing directly onto Lord's to which he had a private entrance at the bottom of his garden. Although in considerable discomfort from a recent hip operation, he fielded all my questions about his fellow tourists fifty years ago with patience and the straightest of bats: 'Wally? One of the best off-side players. Robbie? Magnificent field. Useful hitter. Hedley? Splendid chap. Knowledgeable too. Leslie? A pretty good damn wicket-keeper, don't have any illusions...' His scrapbooks of the tour, beautifully illustrated and compiled with immaculate care, were an exemplification of the Lord's ethos of privilege and high standards. Fools were not to be suffered gladly. Under one photograph of himself leg before wicket to O'Reilly he had written trenchantly, 'A doubtful decision. Note where the ball has bounced!' By a newspaper cutting headed 'Allen's Message To The Daily Mail': 'I refused to accept a telephone call from the paper's editor in England in the middle of the night, so he put in this nonsense...' One only had to look at the set of his jaw, as he made light of the pain he was in, to understand the quality of the man. As we finally shook hands at the door, he relaxed for the first time and smiled. It was less a smile of relief as one of pleasure at another job faithfully done; another chapter of cricket history carefully pointed the Lord's way.

By the time of his death, the following year, a new development project was under way (again with financial support from Getty): the removal of 'the free seats' for the Michael Hopkins-designed Compton and Edrich Stands. Allen himself had been present at the architects' briefing of August 1988, in which he made it clear that the view from the Pavilion of the trees, both

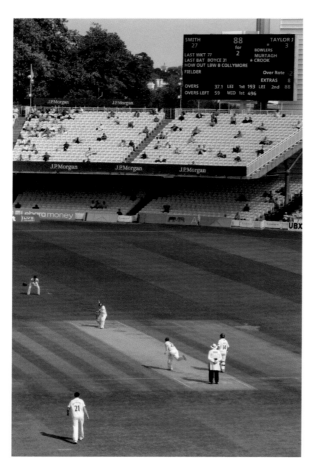

Ancient Rites

Left, championship cricket in capacious modern surroundings. Middlesex's Crook bowls to Leicestershire's Taylor in front of the Edrich Stand. Below, Taylor and Smith return to the Pavilion during a partnership which kept Middlesex at bay for a while. But Middlesex went on to win an engrossing fixture, which the small crowds hugely enjoyed over the four days. The victory helped the home team consolidate a late bid towards promotion to the championship's first division.

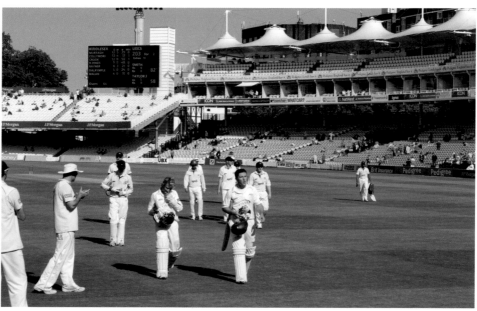

immediately behind the stands and in St John's Churchyard, was sacrosanct, an intervention which ensured that this time good taste defeated pragmatism. But it meant that the new stands (opened by Denis Compton and Bill Edrich's son in 1991) lacked a roof.

The '90s were a decade of much change and architectural vitality. A new academy, replacing the indoor school and opened in 1995, was much more technically advanced than its predecessor. It was followed by the superb Grand Stand, designed by Nicholas Grimshaw to replace Sir Herbert Baker's rotting concrete structure and making most imaginative use of the necessarily limited depth. MCC basked in unaccustomed praise, the *Independent* exulting that 'this apparent bastion of all that is fuddy and duddy' had developed into 'the most energetic patron of modern architecture in Britain'. For all the Grand Stand's size and modernity, it has a restraint which allows it to relate most sympathetically with its various neighbours.

The Lord's advances of the '90s also included electric scoreboards and a refurbished museum, but the culmination of a decade of startling enterprise was the space-age Media Centre, the sealed aluminium box for 200 journalists facing the Pavilion like an elongated Cyclops eye, which won the 1999 Stirling Prize for architecture, attracted important NatWest sponsorship and (at the cost of £5 million) provided Lord's with another image as iconic as Old Father Time. It is probably not a building with which one immediately falls in love. Its location, facing directly across to Verity's opulent piece of Victoriana, is somewhat startling. Yet even the older members now seem to be speaking of it with a growing affection.

At around the same time that the Media Centre was completed, I began to look at Lord's with a fresh perspective as I started assessing for *The Cricketer* the way the county game was being presented around the country. For all its sparkling new facilities, Lord's, alas, featured somewhat low in my annual County Ground League Table, for, although it naturally scored top marks for its viewing facilities, spectators were tending to enjoy a rather warmer welcome in Taunton, better value food at Canterbury, easier parking at Durham, and an altogether greater sense of occasion at Colwyn Bay. Today Lord's would fare rather better. The advent of coloured clothing and Twenty20, plus the wholly admirable (if long-delayed) vote to allow women into MCC membership, may have all been something of a shock to the home of cricket, but they coincided with a lightening of its atmosphere. Lord's, of course, is geared up to promote its big matches – and the Test cricket in the eras of Vaughan and Strauss has been even more extravagant than that of Gower, Gooch and Botham – but it has also made some progress recently in its promotion of the county game. The more I travelled around, the more it seemed that the problem of small attendances at championship games could still be addressed if only the matches' uniquely epic nature was properly grasped and marketed with both imagination and a real determination to expound its subtleties. By the time my three-year watching brief had ended, I was convinced that Lord's, with all its prestige and moral authority, had a key role to play in developing a whole new approach to the Championship, if a sea change were to be effected.

Lord's in the new millennium has further developed its facilities: floodlights have been installed for a five-year trial; much better drainage has resulted from the re-laid playing area; the new Bar and Brasserie beside the Grace Gates are much appreciated; and the multi-million-

pound upgrade of the fabric of the Pavilion, with the creation of a charming roof terrace and the return of the twin turrets as viewing platforms, must surely have made the MCC membership waiting list all the longer. MCC's leadership deserves enormous credit for masterminding the massive £50 million investment which, from the bicentenary of 1987 onwards, has so successfully transformed Lord's into a properly modern sporting arena. And it has not been at the expense of other key issues, like the encouragement of the game at grass roots level. In the past five years alone, for example, MCC has quietly committed £8.64 million to youth cricket.

And what of Lord's' future? It's a thorny question. In 2007 a major development scheme called 'A Vision For Lord's' was introduced, developed at a cost of over £3 million and then, in November 2011, dramatically dropped. When it was first mooted to members, it sounded distinctly exciting and I was among the large majority who responded in its favour. After 200 years of piecemeal development, a 'long-term Masterplan' sounded reassuring. An increase in the ground's present capacity (28,000) by perhaps as much as another 12,000 was an encouragement. No costs were given at this early stage (let alone the awesome figure of £400 million which eventually transpired) and, as regards the funding, this would apparently be met by 'a combination of debenture seat income, a sensible level of borrowing and possible enabling development on the ground's edges'. The stated commitment not to reduce the size of the Nursery Ground's playing area suggested that any 'enabling development' was not going to be too intrusive. So when five tall blocks of flats emerged as an integral and facilitating part of the whole vision, to be placed at the far end of the Nursery Ground facing the Wellington Road, they came as a something of a shock.

The five were reduced to four when a scaled-down version of the project was discussed in November 2011, but, as MCC publicly explained shortly afterwards, the current economic climate now rendered the financial risks just too great. And there was also the matter of the preservation of 'the ground's timeless appeal'. These considerations again proved too strong when, in February 2012, an enhanced offer from the same property developers dangled the carrot of a £110 million windfall in exchange for a 275,000 square foot residential development.

The large sums spent on the vetoed Masterplan caused much understandable negative comment in the media, but there will be some useful long-term benefits from what had been the most comprehensive examination of the ground ever undertaken. A new Ground Working Party has also been established, which will be producing its own short and medium term recommendations. Redevelopment on a building-by-building basis has been mooted, with the Warner and Tavern Stands strong candidates for attention. One of the key issues which will have, at some stage, to be addressed is the future envisaged for the Edrich and Compton Stands, which, in the Vision, were to be given extremely high spectating superstructures. Was Gubby Allen right in 1988 to urge the inviolability of the Pavilion's leafy view? Many would probably think so. Meanwhile, with less immediate pressures on the ground's redevelopment, MCC may possibly have more time for exploring with Middlesex ways and means of pioneering new forms of presentation for the epic four-day games (particularly in those all-important post-tea sessions), whose future is surely tied in with that of Test cricket.

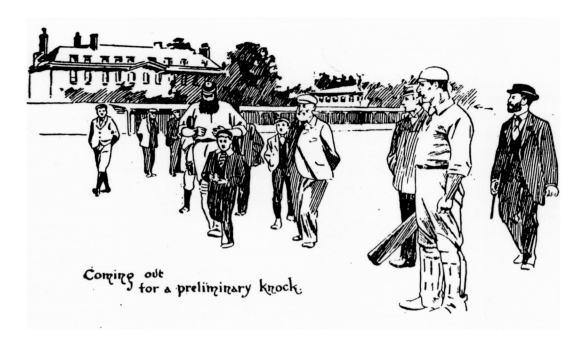

Coming out for a preliminary knock.

Precious Heritage
W. G. Grace having a net at the Nursery Ground on his fiftieth birthday (1898). Below, the same practice area over a century later, with its pleasant blend of modernity (the Nursery Pavilions and MCC Academy) and rusticity. It was here that 'A Vision For Lord's' planned five blocks of flats.

Back in 1946, when Plum Warner's informative book on Lord's was published, it was introduced with a line from the Roman poet Horace, which encapsulated Warner's deep affection for the ground he had served so loyally both as player and administrator: *Ille terrarum mihi praeter omnes angulus ridet.* 'Of all the corners of the world there is none which so charms me.' So many spectators over two centuries must have echoed these sentiments. Though uncertainties may prevail not just about future ground developments but the very nature of county and international cricket, the charm of Lord's burns as brightly today as ever, and, having been identified as something not to be surrendered lightly, will surely delight generations to come, just as it did two young schoolboys, back in the days of post-war austerity, who were lucky enough to be taken to a Test Match with pre-partition India.

Entrepreneurial Flair

Two years before he opened his first cricket ground in 1787, Thomas Lord was working in the wine trade as lessee of the Allsop Arms, Marylebone. He was also a professional ground bowler at the newly formed White Conduit Club in Islington, helping out the gentry whose passion for gambling had found a wonderful outlet in cricket. Lord must have exuded much entrepreneurial flair for the two leading members of this club (the 9th Earl of Winchilsea and future 4th Duke of Richmond) to commission him to find (and then run) a ground with greater privacy. Lord selected a site at Dorset Fields, close to the future Marylebone railway station, and there Marylebone Cricket Club came into being.

Lord had an unusual background as the son of a Yorkshire landowner who had fallen on hard times and become a labourer on the very farm he once owned. At the time he opened Dorset Fields, he was thirty-two, distinctly younger than in the painting reproduced outside today's Pavilion and Tavern, showing him in prosperous middle age. Though the smile looks benign enough at first glance, his steely eyes are a reminder of the occasion when, having grandly offered £20 to anyone who hit the ball out of the Dorset Fields ground, he resolutely refused to pay a batsman who did it.

A sketch of famous cricketers in 1790 suggests that 'Tom Lord' was tall and distinctly dapper in his wide-brimmed hat, smart jacket and knee breeches. In one drawing he is taking a catch with good technique, eyes on the ball as it nestles within cupped hands; in another he is leaning forward at his batting stance, knees bent like Eoin Morgan.

Dorset Fields

Early on in the twenty-three years he ran this ground, Lord put up a fence and charged non-members sixpence for entrance. The large crowds and high stakes – the very first match was played for 100 guineas – both encouraged crime. One newspaper report tells of an unfortunate colonel whose pocket was picked for £30, and of umbrellas, watches and purses being seized by gangs of pickpockets, twenty to thirty strong, 'threatening to stab those who made resistance'. The ground eventually fell victim to housing development, and the last game there was played in 1810 when the Old (or, at least, all those aged thirty-eight or more) vindicated the benefits of experience by defeating the Young by ninety runs. It had a comparatively small playing area (about the size of the Nursery Ground). Today's Dorset Square, where a plaque honours the site, stands on almost a third of it.

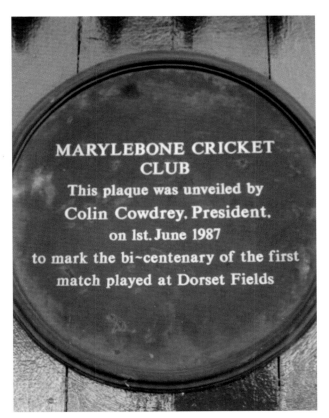

MARYLEBONE CRICKET CLUB
This plaque was unveiled by
Colin Cowdrey, President,
on 1st June 1987
to mark the bi~centenary of the first
match played at Dorset Fields

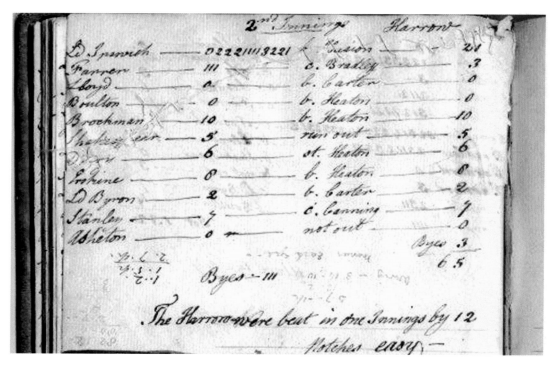

A Historic Fixture

Above, the fourth innings of the first Eton-Harrow match, from an Eton scorebook of 1805. Lord Byron, Harrow's No. 9, boasted to a friend, 'we were most confoundedly beat' but 'I got 11 notches the first innings and 7 the second'. In fact he scored 7 and 2. He seems, however, to have been much to the fore in the two sides' post-match celebrations: 'We were most of us rather drunk and went together to the Haymarket Theatre where we kicked up a row ...'

Lisson Grove

Lord was shrewd enough to have another ground ready, at North Bank, Lisson Grove, when he was priced out at Dorset Fields on the expiry of his lease. But this ground proved much less popular than the first, despite the relaying of turf from Dorset Fields, and no one was too upset when, after only three years, Parliament decreed that the new Regent's Canal should run right through it.

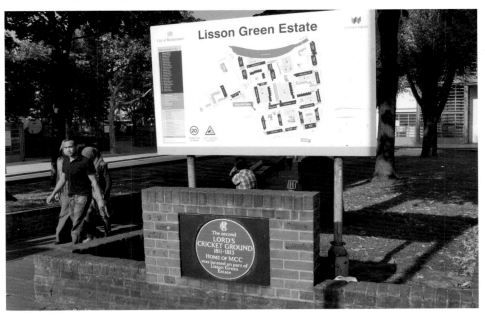

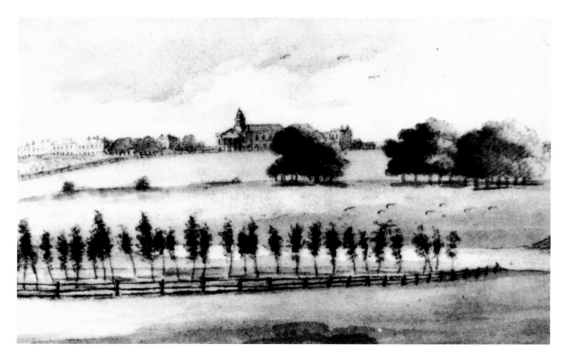

A Countrified Setting

Lord duly moved his precious turf to a third ground, the current one, which he opened in 1814. St John's Wood Parish Church (below), which was built around the same time (initially as a chapel of rest), can be seen in the sketch (above) of 1818, drawn from Regent's Park. Lord's new ground was to the chapel's immediate left. St John's Wood was about to be swallowed up in the great building developments of Regency times.

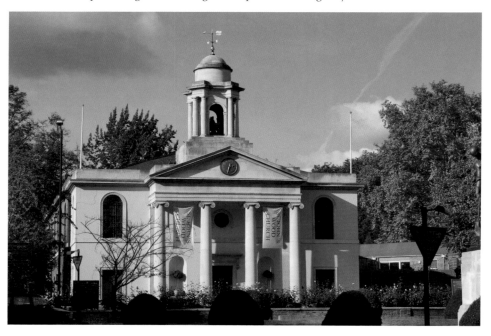

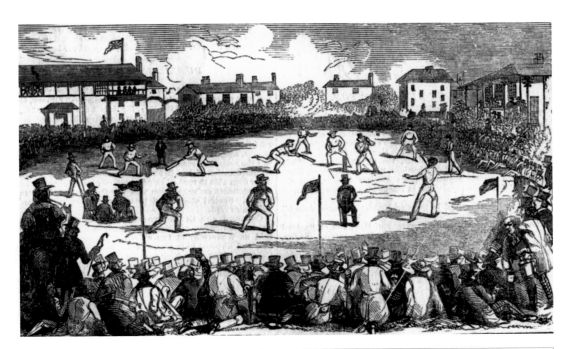

A Male Preserve

This drawing of July 1842 shows the Pavilion on the right and the Tennis Court clubhouse (built four years earlier) on the left, complete with 'scoring perch'. Membership was strictly a male preserve, and was to remain so until a Special General Meeting of 1998 (as announced below) finally led to much-needed change.

The match above was a one-off challenge between an XI with three 'fast' bowlers (Alfred Mynn among them) and another with three slow bowlers (including William Lillywhite, the *nonpareil*). The four innings took place over two days, the team with the fast bowlers winning by 47 runs.

That the match was being played at all was only thanks to William Ward (an MP, banker and fine batsman) who sixteen years earlier had bought the lease (for £5,000) from Thomas Lord. The ground's founder had been on the point of selling it off for building development.

 MARYLEBONE CRICKET CLUB

SPECIAL GENERAL MEETING

Notice is hereby given that a Special General Meeting of Members of M.C.C., called by the Committee in accordance with Rule 22 of the Rules of the Club, will be held at Lord's in the Indoor School on Tuesday 24th February 1998 at 6.00 p.m. The President, Mr. A.C.D. Ingleby-Mackenzie, will take the Chair.

The purpose of the Special General Meeting is to consider and, if thought fit, to approve the following Resolution:-

THAT the Rules of the Club be amended as follows:-

(A) Insert the following sentence at the beginning of Rule 2.2(A):-
"Men and women shall be eligible for membership."; and

(B) Insert the following new Rule 33.3:-
"In these Rules words importing the masculine, feminine or neuter genders shall each include the others."

R.D.V. Knight,
Secretary, M.C.C.
27th January, 1998

Admission to the Meeting will be by production of this Notice.

Rule 24.1 applies as to postal voting. See notes on page 8 regarding voting and procedure.

Conviviality

Above, a detail from a *Punch* cartoon of 'Manners and Customs of ye Englyshe in 1849' which suggests that the members around the simple Pavilion were well catered-for in the provision of drink. There was much for them to gossip about. Their best ground bowler, William Clarke, had three years earlier left to form his own All-England XI, paying his itinerant players more than MCC and threatening to hijack the game in the process. But Lord's continued to develop. The professionals now had their own room attached to the Pavilion; 5 miles of drains had been installed; and just the previous season Fred Lillywhite had started selling match cards from his portable printing tent. Below, while the 40-over Clydesdale Bank Final between Somerset and Surrey plays itself out, there is a relaxed and convivial atmosphere in the Coronation Garden at the back of the Warner Stand.

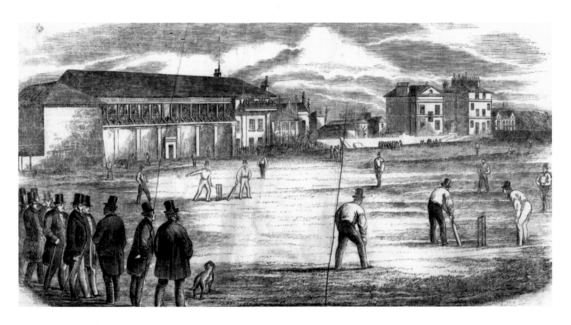

Eye-Catchers

The most impressive building for the first thirty years of Queen Victoria's reign was the Tennis Court clubhouse, on the future site of the Mound Stand (seen below, in 2011). Its facilities (Real Tennis and Racquets courts, a billiards room, dressing rooms and baths) had attracted in the late 1830s an extra couple of hundred members, 'amongst whom are the finest nobles in the land'. In the illustration of 1858, 11 MCC amateurs were playing nine All-Ireland gentlemen and two professionals.

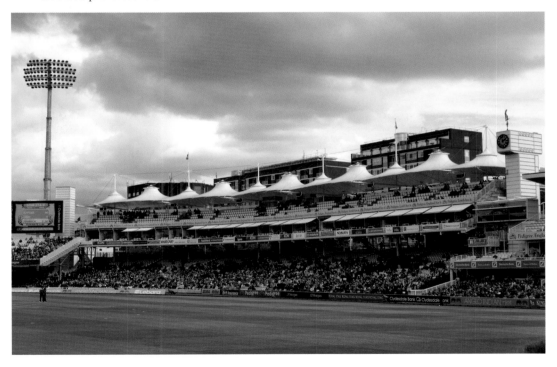

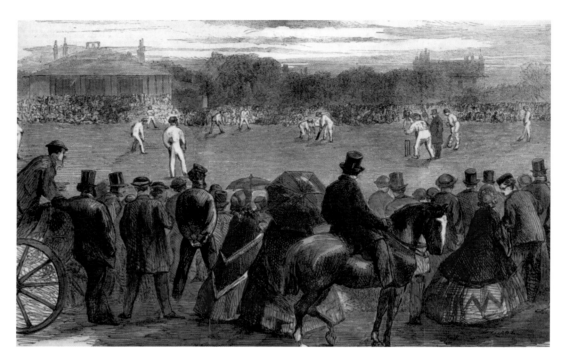

Dark Times

By 1863, when the All England XI were playing their traditional Whitsun fixture (above) with the United All England XI, the ground, though well attended, had been deprived of any improvements in amenities and was again under threat of being built upon. It was to be another two years before its future was assured when MCC finally bought the ground and started major improvements. Below, Sussex's John Wisden, founder of the United All England XI and (in 1864) the longer-lived *Almanack*, commemorated in the Coronation Garden.

John Wisden
1826 – 1884
"The Little Wonder"
Ten Wickets in an Innings, all bowled,
for North v. South at Lord's 1851.
Founder of Wisden Cricketers' Almanack, 1864.

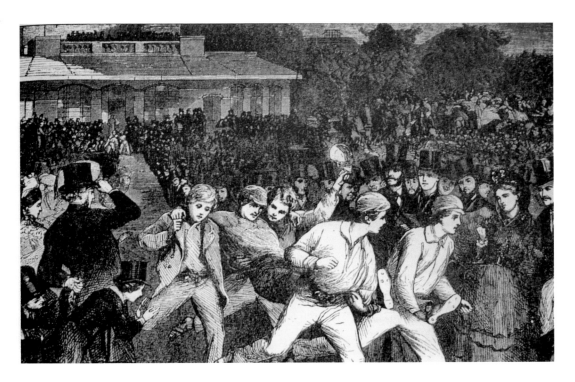

Harris's Arrival

By the time Lord Harris captained Eton in 1870 – he is seen (above) being 'hoist' in triumph – MCC had built a Grand Stand and a new Tavern Hotel, had enlarged and embellished the Pavilion, and appointed their first groundsman and secretary. The public responded. The Eton-Harrow gate takings over the two days were £1,450 and the crowds so great that for the first time no one was allowed inside on horseback. Below, Harris in middle age, already a Lord's fixture.

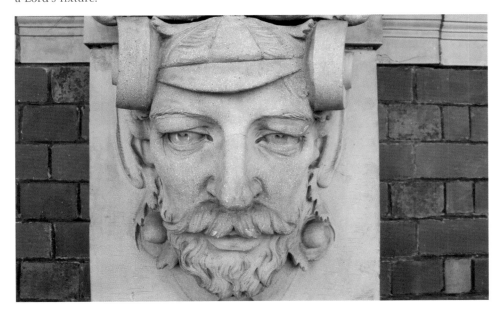

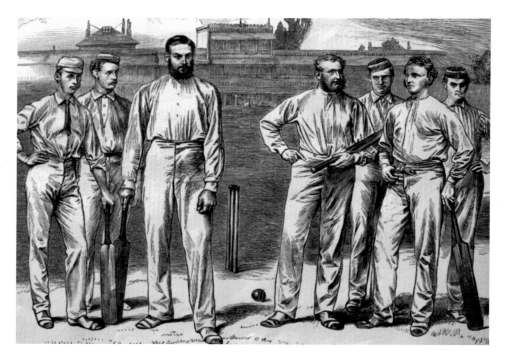

The Leading Gentleman

The tall twenty-two-year-old W. G. Grace dominates 'a group of crack gentleman players' (Gents v Players, 1871) before the recently built Grand Stand. That year Grace scored over 2,000 first-class runs, averaging 78, the beginning of a thirty-year reign, his centuries at Lord's including 181 (MCC v Surrey), 178 (South v North) and 189* (Single v Married), despite the fiery nature of the wickets, which, the previous year, had resulted in a death. Below, Grace reigning in the Coronation Garden.

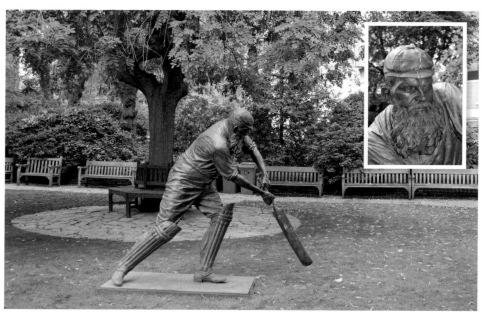

End of an Innings

Frock-coated MCC members greet Lancashire amateur Allan Steel after his match-winning 148 against the Australians in 1884, the first Test Match to be played at Lord's. The England side, captained by Harris (b Spofforth 4) and containing six other amateurs including Grace, won by an innings. Below, not a top hat in sight as Rory Hamilton-Brown leads Surrey Lions into the Pavilion after restricting Somerset to a manageable target in the Clydesdale Bank Final.

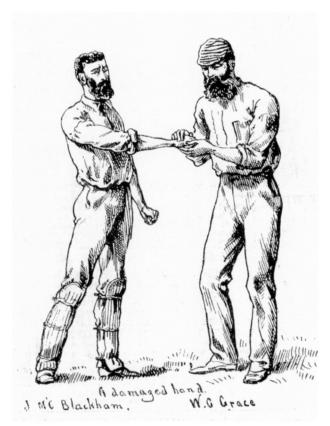

J MC Blackham. A damaged hand. W.G Grace

Medication

During the Test Match of 1884 the great Australian wicket-keeper John Blackham injured a hand when batting. On the advice of England's W. G. Grace, who had qualified as a doctor five years earlier, Blackham retired for further treatment. Grace practised medicine in Bristol for over twenty years, employing two locums in the cricket season. Below, Middlesex batsman Sam Robson retires after a blow on the helmet, when he and Strauss had put on 226 for the first wicket against Leicestershire.

Harris's Domination

The England captain's uncharacteristic lapse in the field in 1884 would not have improved a temper of legendary explosiveness. As a middle-order right-handed batsman Harris (inset) had a modest career average of 26, and his 70 wickets taken with fast round-arm bowling cost almost as much. His MCC domination seems tied in with his overwhelming will to win, exemplified as a schoolboy when running out a Harrovian who'd backed up too far. 'He was surely acting quite correctly in what he did,' Plum Warner later wrote loyally. For all his high-handedness, 'the Big Man at Lord's' (Warner's description) rendered MCC great service. Below, the Harris Memorial Garden of 1934 (designed by Herbert Baker), put to convivial use, the champagne bar masking a flint-and-stone wall which was built with flints from Belmont, Harris's Kent home, to recall at Lord's the old walls on the chalk-lands of his native county.

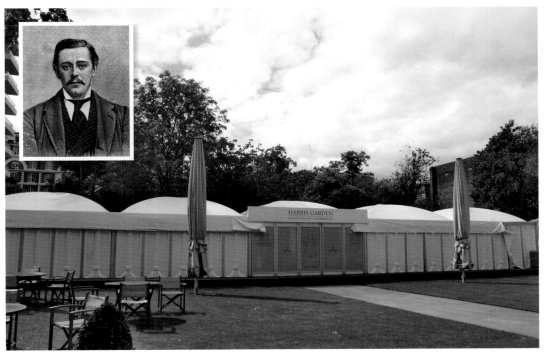

Delicious Handmade Pies

One of the unique delights of the longer format of the game is the need to combine the pleasures of food with those of the cricket. The competitive nature of its acquisition in 1884 makes the modern queues seem very gentlemanly.

Counter-attractions.

Counter-Attractions

Although the vagaries of the English summer are sometimes more conducive to a hot toddy than a cool beer, the slaking of the thirst during the course of a full day's cricket in 1884 added a special touch to cricket's charm, as it still does.

Hon. A. Lyttelton.

The Key Position

With the pitches lively and the saving of byes crucial, England's wicket-keeper in 1884, the Hon. Alfred Lyttelton (great-uncle to jazz musician Humphrey Lyttelton), did magnificently in only conceding 6 over the 2 Australian innings. 'He was a very sure catch,' wrote Warner of him, 'but he did not take the ball so near the wicket as Blackham and Pilling.' When later on in 1884 the Australians were making a big score at The Oval, Lyttelton removed his pads and started bowling lobs with which he took the last 4 wickets very cheaply. One of the seven amateurs in the England team of 1884, Lyttelton had won a blue in each of his four years at Cambridge and was considered the greatest all-round sportsman of his day – an outstanding athlete and tennis player, as well as an England football international.

Lyttelton's work as a barrister and a politician (who became Secretary of State for the Colonies) severely limited his appearances for Middlesex, but such was the grief at his early death in 1913 that a two-minute silence was observed at Lord's in the Varsity Match and the Prime Minister, H. H. Asquith, spoke a eulogy in the Commons: 'He perhaps, of all men of this generation, came nearest to the mould and ideal of manhood which every English father would like to see his son aspire to, and, if possible, attain.'

Below, the rather more colourfully clad Middlesex wicket-keeper, John Simpson, carrying the one piece of equipment most obviously denied Lyttelton, the helmet.

John Swain Eng

Lively Pitches

This final illustration of 1884 was simply captioned 'The pleasures of standing up to fast bowling'. Wicket-keepers of the Golden Age, who preferred to stand up to fast bowlers, were encouraged by the improvements in the quality of the pitches in the 1880s, helped by the acquisition of a heavy roller, named after the ground's founder and pulled by a huge horse called Jumbo, hired from a local tradesman. Jumbo was later replaced by eight young members of the ground staff, pulling ropes attached to the frame and shafts. 'Thomas Lord' remained in use until the end of the Second World War. After spending many years in obscurity, parked between G and H Stands, the roller was refurbished in the mid-1980s (thanks to ground administrator Tony Fleming) and became an exhibit in the Coronation Garden.

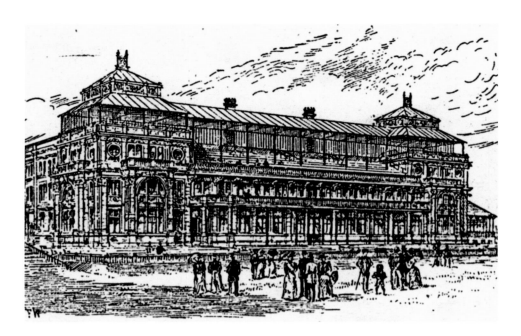

The New Pavilion

The Penny Illustrated Paper's drawing and comments about Thomas Verity's new pavilion in June 1890 were typical of the widespread enthusiasm which greeted it: 'The new Pavilion has been quite a revelation to the numerous visitors who made the Australians' match with the MCC the occasion of their first visit to the classical cricket ground this season. It is a splendid building. There have been other alterations in the arrangements of the ground, all in favour of the spectator, who has always been well cared for at Lord's.'

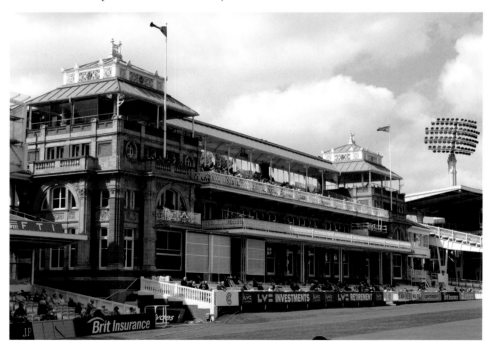

Victoriana

Above, a pavilion detail, suggestive of Victorian plenty. Below, Modern Middlesex players negotiate the celebrated Long Room, passing a famous painting of W. G. Grace batting in front of the old Tennis Court (see page 49). MCC's centenary in 1887 had been marked by the acquisition of Henderson's Nursery and the subsequent creation of the Nursery Ground. But, just as importantly, it also set in motion the need for a new pavilion more appropriate to MCC's standing as the guardian of cricket.

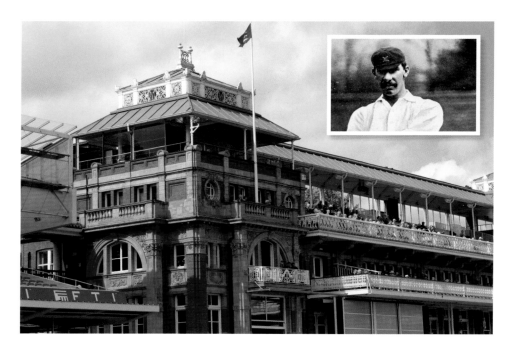

Pavilion Views

The architect chosen, Thomas Verity, had auspiciously been born in 1837, the year of MCC's Golden Jubilee, and his experience with London theatres ensured a most dramatic end product. Verity's Pavilion offers wonderful views (above, from the upper balcony; below, from the writing room) and batsmen have the challenge of hitting a ball right over it. Only one player, Middlesex's Albert Trott (inset), has so far achieved the feat, and that was back in 1899.

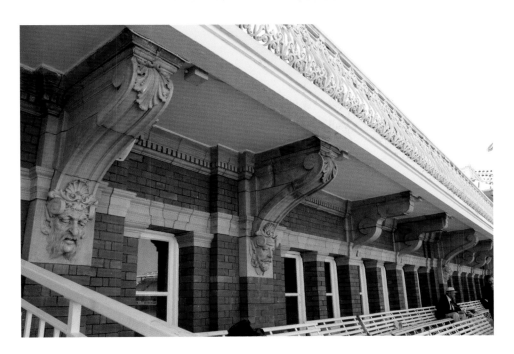

The Pavilion's Two Faces

The Pavilion's chief façade with its imposing classical balance (to which the cantilevered players' balconies of 1906 were a worthy addition) would surely have delighted most of MCC's 3,600 members. There would have been less clutter, too, at the (somewhat prosaic) back of the building, at least before creation of a tennis court block to replace the one demolished in 1899. And though today the rear is truly overcrowded at big matches, that very overcrowding has become part of the Lord's experience.

Beauty and Fashion

The drawings of the 1892 Varsity Match, titled 'Beauty and Fashion', exemplify the purely decorative role in which women were cast at Lord's for so many years. But the revolution did eventually arrive, and women's cricket, whose history goes back to 1745, suddenly started a new era when, in 1999, MCC Women played their first match and ten outstanding women cricketers became Honorary Life Members. In 2009 England Women won the ICC World T20 at Lord's.

Below, a sign of better times, Claire Taylor's record-breaking 156* duly celebrated. Honoured with the MBE and selection as one of *Wisden*'s Cricketers of the Year, Claire Taylor scored a record eight centuries for England in her ODI career. An accomplished violinist, she read Maths at Oxford (where she was also a star hockey player) before taking a job in IT management, which she gave up to concentrate on a full-time cricket career.

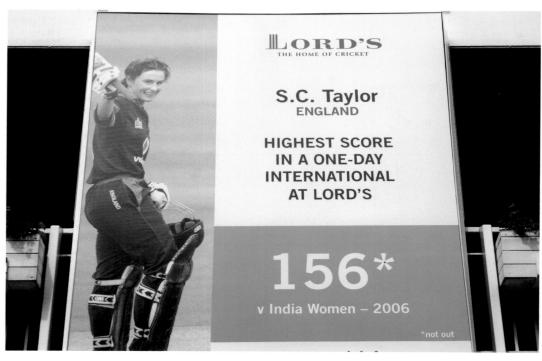

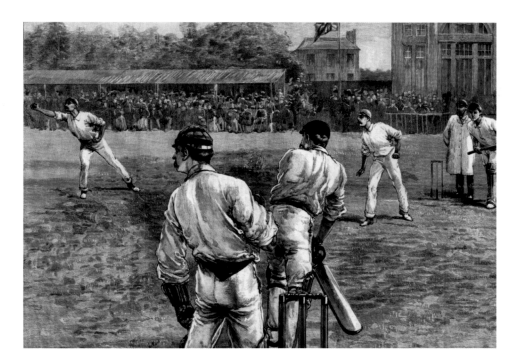

County Prestige

The Counties finally organised themselves into a championship competition in 1873, Middlesex first playing at Lord's four years later. As professional football slowly followed cricket in taking full advantage of the public's greater leisure and better transport, crowds flocked to championship matches. Above, Notts' Arthur Shrewsbury had shown 'all his old mastery in placing the ball and never running the slightest risk' before being caught by Middlesex's Phillips off Rawlin for 212. Below, a celebratory First Day Cover, signed by four of the county's great names.

MIDDLESEX C.C.C.

CENTENARY

AT LORD'S GROUND

SILVER JUBILEE
E R
1952 8½P 1977

MIDDLESEX C.C.C. CENTENARY
Australia v Middlesex
20 AUG 77
LONDON N.W.8.

STAMP PUBLICITY
1 HIGH STREET
WORTHING, SUSSEX

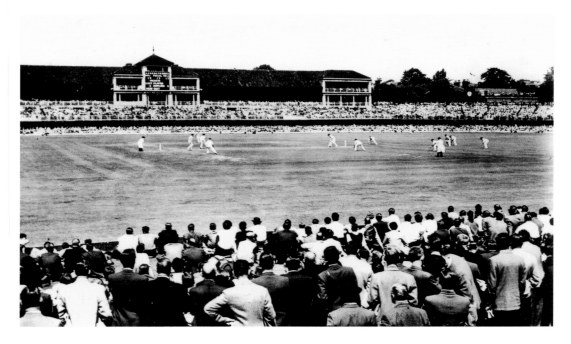

The Three Grand Stands

Above, the Herbert Baker design, the second Grand Stand, opened in 1926. Below, the splendid Nicholas Grimshaw Grand Stand of 1998, but looking somewhat forlorn in a poorly attended county match, when only one side of the ground was open to the public. Inset: the first Grand Stand (built in 1867 with a private box on top for the Prince of Wales) during the Varsity Match of 1892 (see also page 28).

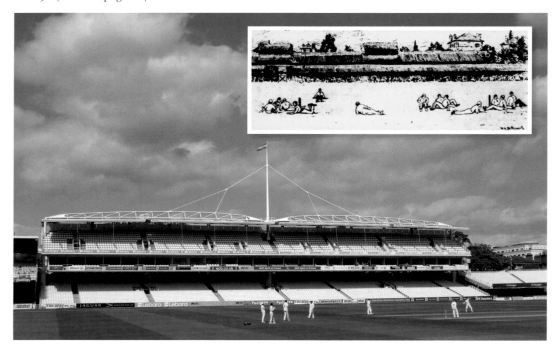

MIDDLESEX-v-GLOUCESTER. AT "LORDS"

The Doctor Catches Webbe at Short Leg — but Illustrates "Butterfingers" in missing Stoddart at Extra Mid-off — Stoddart.

Ferris Bowling.

Position of the Field when Stoddart left. — James Procter del.

Media Support

Cricket's Golden Age had the good fortune to coincide with a large increase in popular newspapers and magazines, many of which were fully illustrated. Not all the artists knew their cricket – Middlesex's high-scoring A. E. Stoddart is unlikely to have enjoyed a successful career as depicted (in 1894) – but coverage of county matches was an enormous boon to the growing interest in the new Championship. Though the newspapers' coverage of county matches has severely diminished in recent years, television's is outstandingly good. Below, Michael Atherton interviews the Surrey and Somerset captains, Rory Hamilton-Brown and Marcus Trescothick, before the start of their one-day Final.

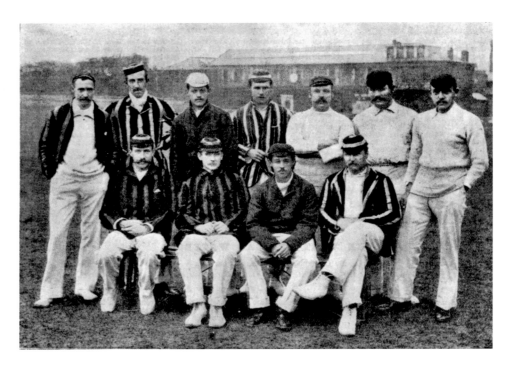

Increased Capacity

Today's capacious new Mound Stand (below) makes a fine, if somewhat ghostly, backdrop to a county match in 2011. Above, just visible in the gloom behind the Middlesex XI, is the Tennis Court building, which made for less expansive viewing from the same site. Middlesex were captained by A. J. Webbe (second seated from left). Stoddart (first left) was about to take his own team to Australia. Rawlin and Phillips stand third and second from the right.

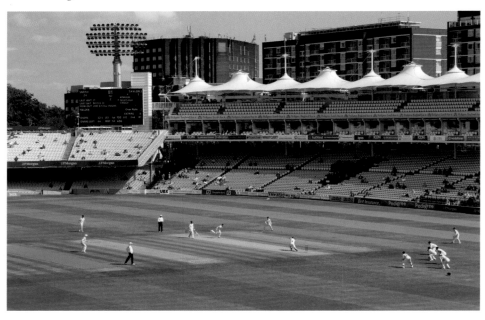

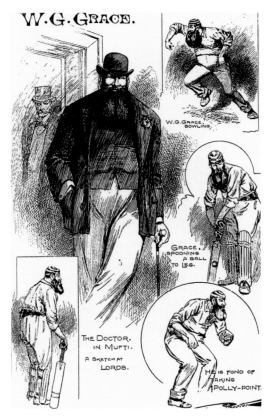

The Great Cricketer

W. G. Grace, a much-loved national celebrity, created extra attention in 1895, at the age of forty-seven, by scoring 1,000 runs in May, the first time the feat had been achieved. The Grace Gates are today such an integral part of the ground that it's a surprise their designer, Herbert Baker, for long championed a very different memorial, a wall enclosing a bust of W. G. at the far end of the ground from the pavilion. Despite support from his friend Lord Harris, the Committee held firm on the idea of gates, which were completed by 1922. Baker's interesting ironwork contains, as a symbol of the game, red balls surrounded by the golden rays of the sun, an idea inspired by a poem of E. V. Lucas. Baker later wrote with satisfaction: 'E. V., a lover and writer of the game, was very pleased with this application of his poem.'

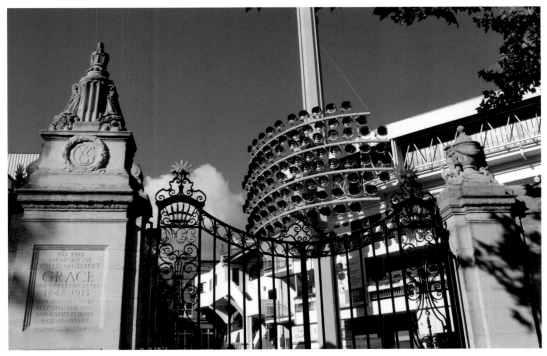

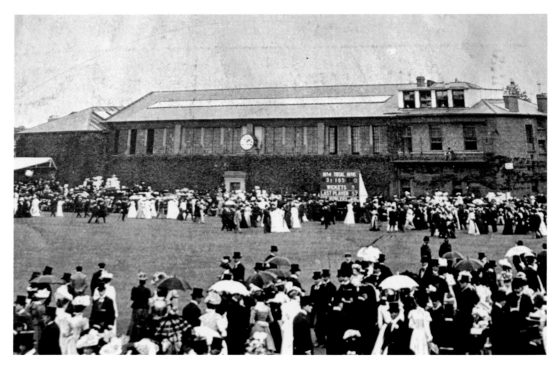

Archery made its Olympic debut at Paris 1900, was dropped from the programme after the 1908 Games, and then returned for a single appearance in 1920. After a 52-year gap, the sport was reintroduced at Munich 1972 and has remained on the Olympic programme ever since.

Other Sports

Lord's has always accommodated other sports as and when the opportunity has arisen. The Real Tennis Court, for example, its skylight plainly visible on the roof in the picture above, was a case in point, erected at a huge cost of £4,000. When it was eventually pulled down (shortly after this photograph was taken at the Oxford and Cambridge match of 1898), a new court was soon built behind the Pavilion, and physically attached to it to allow the use of the existing changing rooms. Below, an advertisement at Lord's in the summer of 2011, alerting the public to the hosting of archery in the coming Olympics, another financially beneficial piece of sporting diversification.

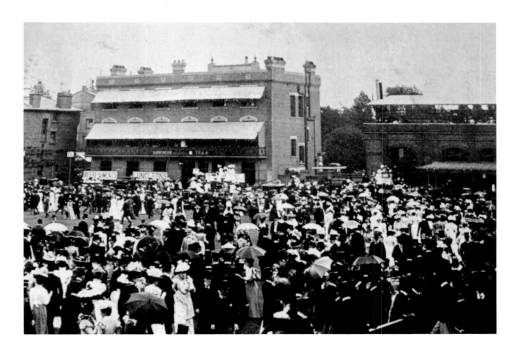

Gin and Other Tonics

The ground's second Tavern, originally called Lord's Hotel and only thirty years old at the time of the 1898 Varsity match (above), was created through the generosity of William Nicholson, a rich MCC member whose family was in gin. (MCC around this time altered their colours from light blue to red and yellow, the same colours which just happened to be on the Nicholson gin labels.) Though this Tavern was to perish after a most popular existence of 100 years, its ethos has prevailed.

THE DOCTOR
RUN OUT

Disaster and Consolidation

The illustration from the Gents v Players match of 1899 tells of a national disaster: the fifty-one-year-old W. G. Grace's dismissal when all set for another century. The great man was called for an impossible single and run out by too many yards for any umpire, however sympathetic, to ignore. The care the artist has taken with the background reflects interest in a major ground improvement that year, the building of the first Mound Stand on the site of two houses facing St John's Wood Road and the old Tennis Court. Two years later the stand would be given a canvas covering. Below, the much altered modern view: the weather vane with Old Father Time removing a wicket's bails (Herbert Baker's personal gift to the second Grand Stand in 1926) can be seen in its new position on top of the lift tower between the Mound and Tavern Stands.

England's Defeat at Lord's.

LAST SATURDAY.

WHEN HAYWARD WAS CAUGHT BY TRUMBLE IN THE SLIPS, ENGLAND'S HOPE VANISHED

ENGLANDS CAPTAIN PLAYS AGAINST THE AUSTRALIANS. AND FATE COMBINED

'BRAVO! ARCHIE. 88 NOT OUT.

DARLING MAKES THE WINNING STROKE.

GREGORY ON THE TRAIL

'THE DOCTOR' LOOKED QUITE PLEASED THAT HE WAS NOT IN THIS MATCH

The Ubiquitous Doctor

Having captained England at Trent Bridge in 1899, Grace was summarily dropped for the Australian match at Lord's, Archie MacLaren replacing him in the team and as captain. Grace still managed, however, to maintain good media coverage. Below, the painting by Archibald Stuart Wortley, commissioned by MCC by subscription 1888–90, which graces the Long Room, was much in evidence around the ground in the summer of 2011, nearly 100 years after his death.

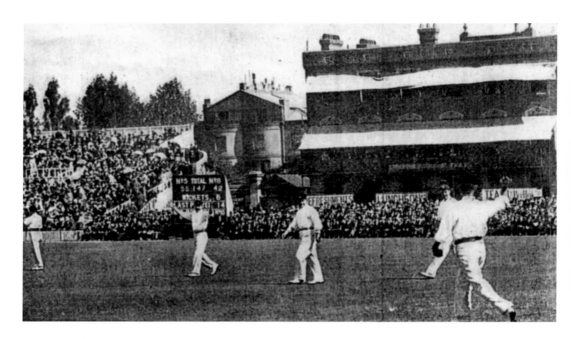

Scoreboards

Above, in 1899, a small scoreboard between the Tavern Hotel and new Mound Stand tells of a small Jackson-Jessop fight-back before centuries by Trumper and Hill won the Test Match for Australia. Inset: the scoreboard centrally positioned in the second Grand Stand, telling of an England bowling success against India in 1974. Below, one of three electronic boards in modern use; a fourth and final one is mooted for the Warner Stand.

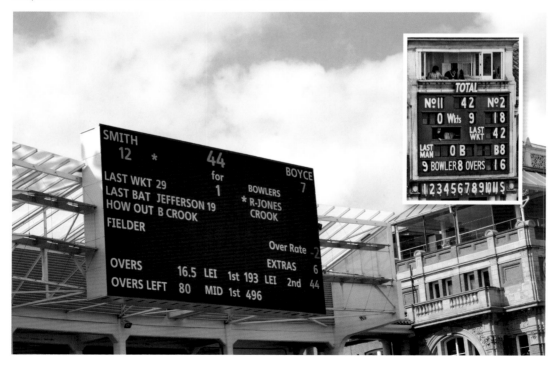

Moments Of Truth

110 years may separate the two illustrations but the drama of bat v ball is undiminished. Above, a formally dressed crowd watches Eton play Harrow in 1901, only one year after the clock tower was built to display the timepiece removed the Tennis Court building. It would be another thirty-three years before Herbert Baker's Q Stand replaced Block D (later Q) next to the Pavilion, a popular area, though only the seats towards the back were under cover. The Refreshment Room Extension, to the left of the clock tower, had even more social cachet, for beneath its top floor of 400 seats were seven boxes for VIPs. Below, the crowd may be more informally dressed and somewhat smaller for the second day of Middlesex v Leicestershire, but concentration is just as intense as Collymore bowls to Taylor. Championship cricket is so full of quality these days it deserves vigorous promotion.

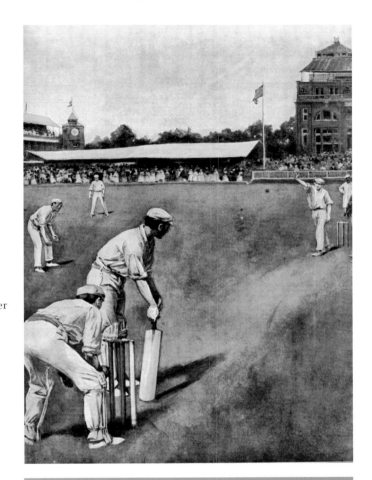

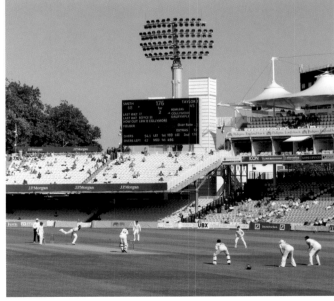

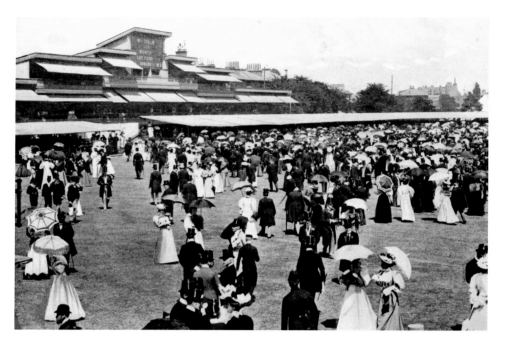

1st and 3rd Grand Stands

That the Oxford and Cambridge match was a part of the London Season helped boost attendances at the turn of the century, but the high quality of cricket also played its part in filling the Grand Stand. University Admission Tutors favoured sport. Below, the latest Grand Stand reflects more egalitarian times, though the hospitality boxes and the funding via debentures hint at exclusivity, and the MCC flag keeps a discreet distance from all the advertising.

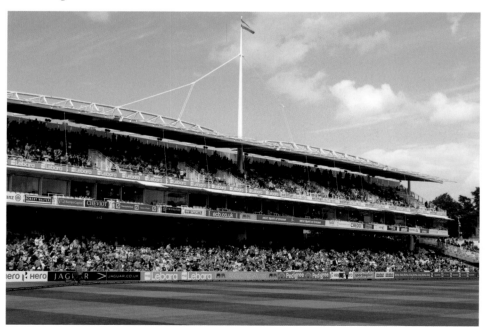

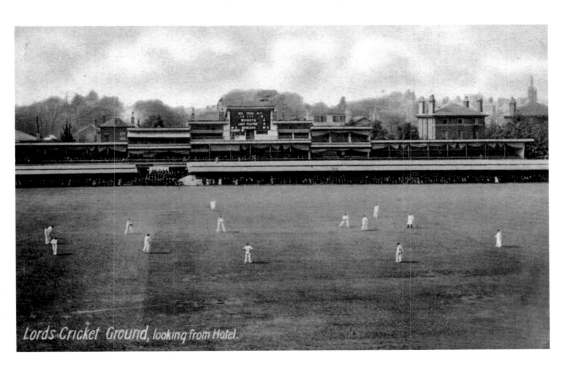

Lords Cricket Ground, looking from Hotel.

1st and 3rd Grand Stands

The latest Grand Stand was closed to all but hospitality box holders in Middlesex's 40-over fixture with Sussex in 2011, the bulk of the spectators sitting on the Tavern side of the ground as this classic off-drive was played. There's certainly a buzz around the 1st Grand Stand in the top picture. Comparison with the drawing on page 42 shows the results of at least one major improvement scheme.

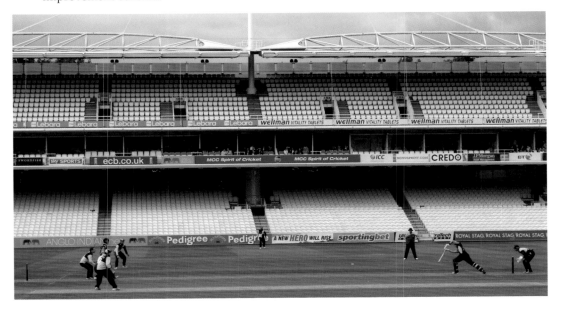

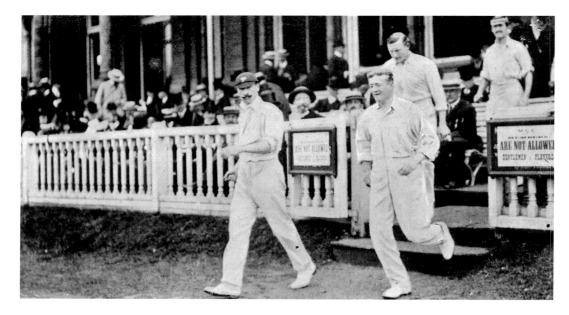

The Captains

Above, the Yorkshire all-rounder Stanley Jackson, back from active service in the Boer War, leads out the Gentlemen in 1904, followed by H. K. Foster and A. O. Jones (skippers of Worcester and Notts). Educated at Harrow and Cambridge, Jackson went into politics and as Governor of Bengal adroitly survived an assassination attempt. He never captained Yorkshire. (Lord Hawke had the job.) Below, Matthew Hoggard, Yorkshire's leading swing bowler for many years, likewise never captained Yorkshire, but a late career move saw him leading out Leicestershire.

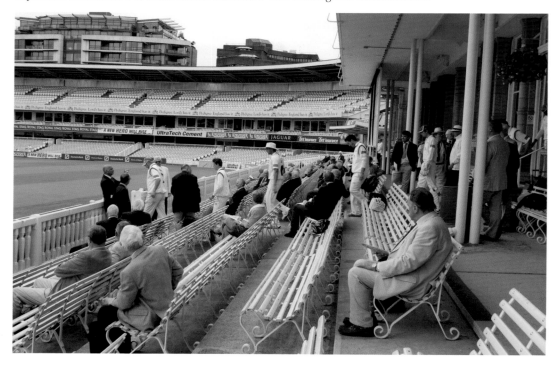

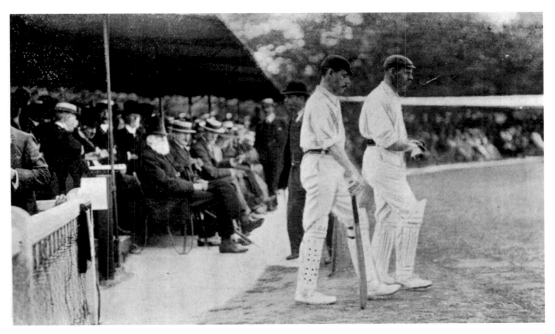

Togetherness

When the new Pavilion opened in 1890 it was only for use by the amateurs, the professionals having their own changing rooms beside it, from which, above, the Leicestershire left-hand all-rounder John King and Surrey's great opening batsman Tom Hayward can be seen issuing forth (Gentlemen v Players, 1904). The pavilion rails are visible far left. The narrow confines of Block A (just three rows deep when inaugurated in 1874 but subsequently enlarged) curve round in the background, occupying the site taken today by the Warner Stand.

Below, the Leicestershire players, having come down the central steps of the Pavilion, demonstrate that modern *sine qua non* of team sports, the group huddle. Alas for the huddle, they still lost quite heavily.

Gentler Days

Above, a *Punch* cartoon of 1909 pokes gentle fun at maternal ignorance at the Eton-Harrow match: Fond mother (calling attention to the total on each telegraph board): 'Oh Clarence, look how close the two sides are keeping to each other.' Below, Sky news reporter Gary Cotterill outside the East Gate reporting on the jailing of 3 cricketers for corruption, November 2011.

Tavern Views

One of the most popular places to watch the game a century ago was from in front of the old Tavern, even if visibility was minimal at big matches, as this *Punch* cartoon of 1909 suggests: Late arrival: 'How's Australia doing?' Patient enthusiast: 'Well, I should think they must be having tea. It's some time since I heard anything.' The spectators in the cartoon are shown in the wide space in front of the old Tavern Hotel (which stretched all the way back to St John's Wood Road).

Below, spectators now move behind, rather than in front of, the modern Tavern Stand before joining the old route behind (now under!) the Mound Stand.

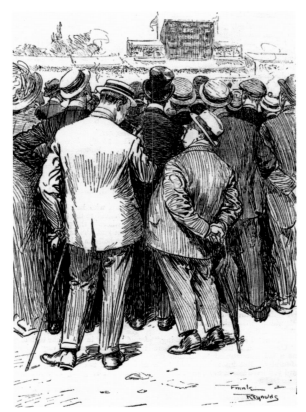

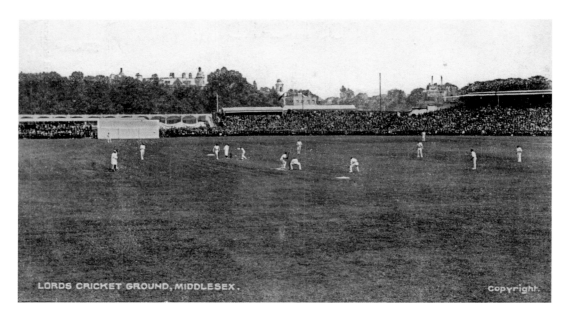

LORDS CRICKET GROUND, MIDDLESEX. Copyright.

The Nursery End

A Test Match in the early 1900s, showing the new Mound Stand (1899, far right) and Arbours (1903, back left), open-fronted shelters for picnic luncheons. The Nursery Ground came into being in two stages: a market garden (Henderson's Nursery) acquired in 1887, and a Girls' Orphans School in 1896 (one of the old orphanage buildings is visible behind a stand, near the parish church's cupola). Below, the same view 100 years on. Only the trees behind the stand celebrating Bill Edrich (inset) are immediately recognisable.

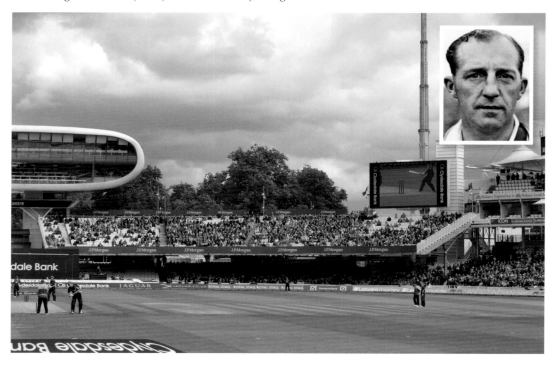

The Great War

County cricket was soon brought to an end when, in late July 1914, Britain was caught up in the First World War, and the Army was offered the use of the ground for training purposes. This postcard and the two following date to within only four weeks of the declaration of war, the young man in uniform being a certain Guy Barton. 'Many thanks for cigarettes and letter,' he wrote on the back to his sister. 'How do you like this?'

The eleven-year-old arbours of the Nursery Ground in the background appealed in an era when picnicking at big matches was taken as seriously as the cricket itself. The arbours helped do away with some of the marquees which damaged the turf. With their gas and running water, cupboards and sinks, they were also extremely useful for army trainees.

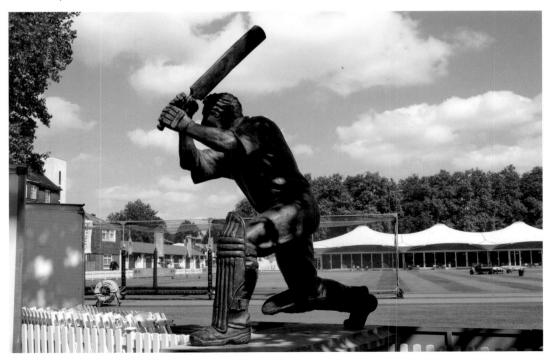

The Great War

'We are at Lord's,' explained Barton to his sister. 'Thought you would like to see a pretty picture of me feeding.' Wartime units stationed at Lord's included the Territorial Army, the Army Service Corps and the RA Medical Corps. Occasional charity matches were played during these four otherwise barren years. Barton had moved on by the time he sent the lower card: 'Am so sorry you did not receive sincere thanks for cigarettes. We are now at the Tower.' He would probably soon be in France.

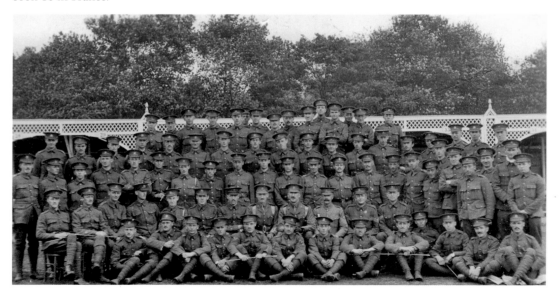

Plum 1920

County cricket resumed in 1920 and, in this, his last season, the forty-six-year-old Plum Warner captained Middlesex to championship success. The cap which he usually wore displayed the colours (dark blue, maroon and buff) of the Harlequin Club, open only to current and past members of Oxford University who have played first-class cricket. Douglas Jardine also favoured it.

Dress Codes

Above, 'Four Middlesex Amateurs' illustrated in *The Cricketer* of June 1921, the magazine founded that year and edited by Plum Warner. Their dress recalls cricket's earlier Golden Age, with colourful emphasis on socially exclusive clubs, whereas the Surrey XI (below) in a one-day Final subscribe more to the collaborative team ethic and the endorsement of a South Korean motor company. Gerald Crutchley, the Honourable Clarence Bruce, Nigel Haig (Lord Harris's nephew) and Frank Mann, as seen left to right, were talented all-round sportsmen who had survived the horrors of the Great War (Crutchley spending nearly four years as a prisoner-of-war). Both Mann and Haig became long-term Middlesex skippers. The big-hitting Mann once dispatched Wilfred Rhodes three times in as many balls to the top of the pavilion. Bruce was a key administrator in the 1948 London Olympics.

Patsy

Hendren (son of a Turnham Green plasterer whose Irish family name used to be O'Hanrahan) poses on the Nursery Ground in the 1920s. Short, stocky and full of blarney, he enlivened Lord's in a thirty-year career which took in an awesome 57,611 runs at an average over 50. His Test average was almost as good. His style was his own, his strong forearms encouraging jabbed, rather than flowing, drives. Plum Warner, who took him under his wing, wrote in 1920 that he 'possesses an amazing number of strokes, and there has certainly never been a finer hooker of a short ball. But it was his ebullience and good nature which endeared him to everyone.' Hendren was equally warm about his former captain: 'Mr Warner it was who fashioned my cricketing thoughts, my style – in fact my everything. What I did wrong or right was for PF to blame or praise.'

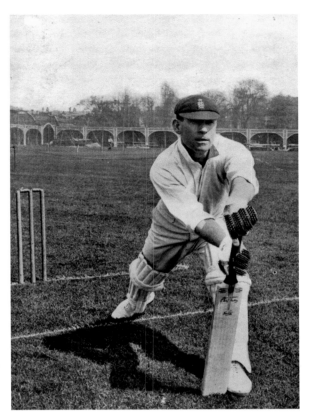

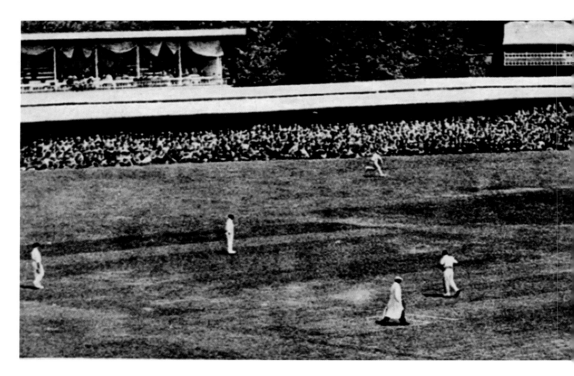

A Fragile Batting Unit

England's opening pair, Alf Dipper and Donald Knight, at the beginning of the 1921 Test which the all-conquering Australians won easily, thanks to the pace of Gregory and McDonald and the spin of Mailey. England tried thirty players that series. The highly gifted Knight, a full-time schoolmaster, played only one other Test and the dogged professional Dipper none. Below, only the trees and the clock date back to the 1920s.

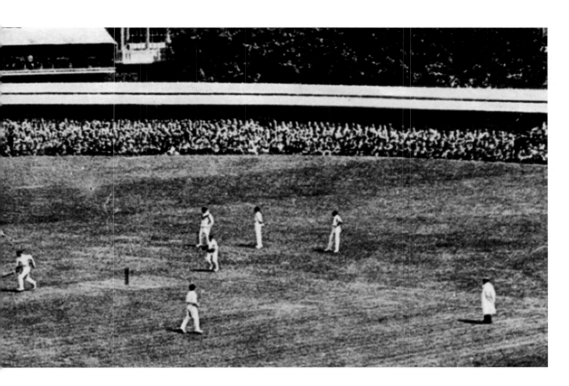

Rooms With No View

A series of fairly humble buildings – the last at Lord's to be designed by Thomas Verity's son, Frank – erected just after the war. Their balconies provided a good view of the cricket before Herbert Baker's new stands took it away. The westernmost building of this group, now somewhat dwarfed by the Compton Stand, was used for many years as offices for the International Cricket Council.

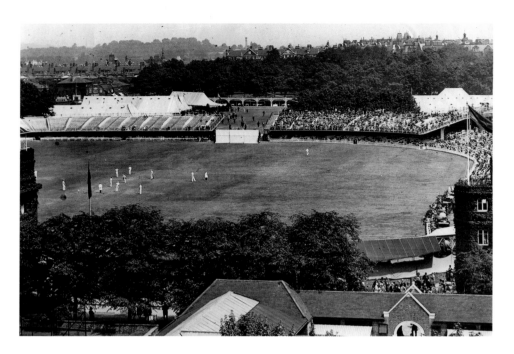

Lord Harris's Architect Friend

Sir Herbert Baker (inset), who lived near Lord Harris and played for Harris's Band of Brothers, effected immense changes in the 1920s. Above, the Eton-Harrow match of 1928, showing Baker's 'free seating' (Stands F/G and H/I) which linked up with his Grand Stand (below, in the early 1960s). Baker made his name in South Africa and India, where eye problems eventually ended his own club cricket: 'I began to miss catches in the glaring African sun, and to fail to score as quickly as I used to do.'

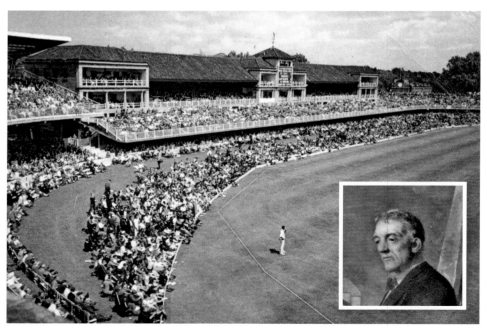

Matches for the Season at Lord's, 1929.

—o—

MAY.

Wed.	1	Anniversary Meeting at 6 p.m. and Dinner at 7 p.m.	
Wed.	1	M.C.C. v. Surrey ...	3 days
Sat.	4	M.C.C. v. Yorkshire...................................	3 days
Wed.	8	Middlesex v. Leicestershire	3 days
Sat.	11	Middlesex v. South Africa	3 days
Wed.	15	Middlesex v. Gloucestershire	3 days
Sat.	18	Middlesex v. Sussex	3 days
Wed.	22	Middlesex v. Worcestershire	3 days
Sat.	25	Middlesex v. Notts	3 days
Wed.	29	M.C.C. v. Royal Artillery (Band if possible)	2 days
Fri.	31	Beaumont College v. Oratory School	1 day

JUNE.

Sat.	1	M.C.C. v. South Africa	3 days
Wed.	5	Middlesex v. Warwickshire	3 days
Sat.	8	England v. The Rest (Test Trial Match)	3 days
Wed.	12	Middlesex v. Hampshire............................	3 days
Sat.	15	Middlesex v. Lancashire............................	3 days
Wed.	19	Middlesex v. Somerset	3 days
Sat.	22	Middlesex v. Yorkshire	3 days
Wed.	26	M.C.C. v. Cambridge University	3 days
Sat.	29	England v. South Africa	3 days

JULY.

Wed.	3	M.C.C. v. Oxford University	3 days
Mon.	8	Oxford v. Cambridge	3 days
Fri.	12	Eton v. Harrow	2 days
Mon.	15	Royal Artillery v. Royal Engineers (Band if possible) ...	2 days
Wed.	17	Gentlemen v. Players	3 days
Sat.	20	Middlesex v. Derbyshire..........................	3 days
Wed.	24	The Navy v. The Army (Band if possible)	3 days
Sat.	27	M.C.C. v. Lords and Commons	1 day
Mon.	29	Clifton v. Tonbridge	2 days
Wed.	31	Rugby v. Marlborough	2 days

AUGUST.

Fri.	2	Cheltenham v. Haileybury..........................	2 days
Mon.	5	Lord's Schools v. The Rest.........................	2 days
Wed.	7	The Army v. The Public Schools	2 days
Fri.	9	Young Amateurs v. Young Professionals..........	2 days
Mon.	12	M.C.C. v. Royal Engineers (Band if possible)	2 days
Wed.	14	Middlesex v. Essex	3 days
Sat.	17	R.A.S.C. v. R.A.O.C. (Band if possible)	1 day
Mon.	19	M.C.C. v. Ireland....................................	2 days
Wed.	21	M.C.C. v. Wales	3 days
Sat.	24	M.C.C. v. Indian Gymkhana	1 day
Mon.	26	Boys' Match (under 16)	2 days
Wed.	28	Middlesex v. Kent	3 days
Sat.	31	Middlesex v. Surrey.................................	3 days

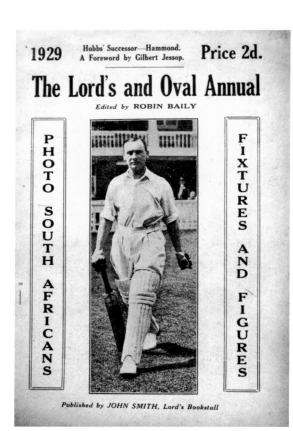

1929 Hobbs' Successor—Hammond. A Foreword by Gilbert Jessop. **Price 2d.**

The Lord's and Oval Annual

Edited by ROBIN BAILY

PHOTO SOUTH AFRICANS

FIXTURES AND FIGURES

Published by JOHN SMITH, *Lord's Bookstall*

The Lord's Shop

By the 1920s there was a very popular bookstall run in conjunction with a similar bookstall at The Oval. One of their publications, an Annual for 1929, most fittingly featured Jack Hobbs on the cover. Three years earlier the great Surrey batsman had achieved the highest score ever made at Lord's 315* for Surrey v Middlesex, a record which was to stand until Graham Gooch's 333 in 1990 against India. By the time of the Tavern's demolition in the 1960s the bookstall had gone and a Lord's shop was operating from the East Gate Lodge. This was replaced in 1996 with a purpose-built establishment, designed by David Morley, its high-tech specification including a translucent roof to allow natural light. MCC was soon quadrupling its shop revenue. Morley was also responsible at this time for the adjacent ECB Headquarters Building, which is similarly 'green' and futuristic, with 'sun shelves' on the exterior helping obviate dependence on artificial lighting.

2d. Lord's Ground.

MIDDLESEX v. LANCASHIRE.

SATURDAY, JUNE 15, 1929. (Three-day Match.)

LANCASHIRE.	First Innings.		Second Innings.
1 Ha'lows	b. ALLEN	12	
2 Watson	b. ALLEN	47	
3 Tyldesley, E.	b. ALLEN	102	
4 Iddon	b. ALLEN	0	
5 Hopwood	c. PRICE b. ALLEN	48	
6 Halliday	b. ALLEN	0	
*7 Farrimond	b. ALLEN	6	
†8 P. T. Eckersley	NOT OUT	8	
9 Tyldesley, R.	b. ALLEN	0	
10 Macdonald	ST. PRICE b. ALLEN	1	
11 Hodgson	b. ALLEN	0	
	B , l-b , w , n-b , 17		B , l-b , w , n-b ,
	Total 241		Total

FALL OF THE WICKETS.

1- 23 2- 102 3- 102 4- 215 5- 215 6- 228 7- 239 8- 239 9- 241 10- 241

Plum's Protégé

When twenty-seven-year-old Gubby Allen turned up twenty minutes late one Saturday in June 1929, he seemed unlikely to create a Lord's record (still unsurpassed) of ten wickets in one county innings. He'd recently played very little cricket for Middlesex and arrived in a rush from his new job as assistant to Debenham's General Manager. Nigel Haig quickly flung him the ball. Lancashire were batting and 20,000 watching. And so began the first of four fiery spells from the Pavilion end, 'a truly exhilarating exhibition of fast bowling', Allen taking 7–13 in his final eleven overs, and ending up with figures of 10–40. The most bizarre of the dismissals was that of the Australian Ted McDonald, who, having bravely given the furious Allen the charge, saw the gentlest of balls floating past his flailing bat and was ignominiously stumped. Below, Herbert Baker's Q Stand, renamed in Allen's honour in 1989, sixty years later.

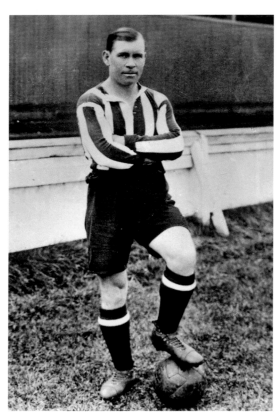

The Outside-Right

Patsy Hendren in 1925 as captain of Brentford, where he played outside-right for many years (1911–27), after youthful stops at Manchester City, Coventry and QPR. He also played for England in a Victory international. Contemporary reports praised his persistency and 'the way with which he forces his way through the defense to finish with a terrific shot'.

He first played for Middlesex as an eighteen-year-old (in 1907) winning his cap after only 21 of his 581 Middlesex matches: 'That was a great day for me. I was called into the amateur quarters at Lord's and there was my skipper, P. F. Warner. After a little speech, full of the wisdom of cricket, I was told to go down on one knee. And then the county cap was duly placed on my head.' Below, a memorial bench on the Nursery Ground. Perhaps one day a bigger memorial might be given him. Only Hobbs, after all, has ever scored more first-class centuries than Hendren's 170.

Tight-lipped Modesty

Jack Hearne's skills were of an all-round nature, his careful batting, which brought him 96 centuries, complemented by leg-breaks and googlies (taking 1,839 wickets at 24 each). Hearne, who came from a family of wheelwrights in Buckinghamshire, was as reserved as Hendren was voluble and a stickler for correct dress and behaviour. Hendren wrote of him: 'The year after I blew into Lord's as a boy another youngster came onto our staff. A slip of a kid, rather pale, nothing special to force your attention, but one we soon all began to watch and wonder at. This was Jack Hearne, breaker of bowlers' hearts ... Like my own, his first job was that of programme merchant. Let me make the confession – we were both dodgers. We were both more in love with the game than wanting to run around with those "krekt kards!" ... Jack is a more stylish bat than myself. He plays more correctly. He is, in fact, the most correct player in the game ...'

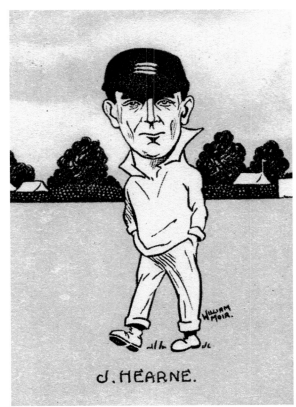

J. HEARNE.

IN MEMORY OF J.W. HEARNE (MIDDLESEX AND ENGLAND) 1891 - 1965
M.C.C. MEMBER 1949 - 1965

Rain-Stopped Play

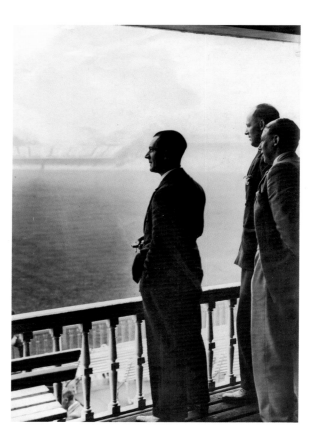

The unflappable Jack Hearne looks nonchalant enough as, cigarette in hand, he surveys an empty ground in bleakly dark and damp conditions on his Whitsun Benefit Match in 1932, supported by team-mate Durston and Sussex's Maurice Tate. Only one day's play was possible, so he lost the considerable match receipts he would ordinarily have expected, though a generous subscription list and collections softened the blow. And this was, unusually, a second benefit, a token of his long and valuable service to the county.

Below, revolutionary modern equipment and much improved drainage combined to allow the one-day Final between Surrey and Somerset to be completed in one day. The Hover Cover, designed by Stuart Canvas Products and installed experimentally at Lord's in 1998, has been a major step forward in the protection of square and pitches, needing less manpower for a speedier (three-minute) end result.

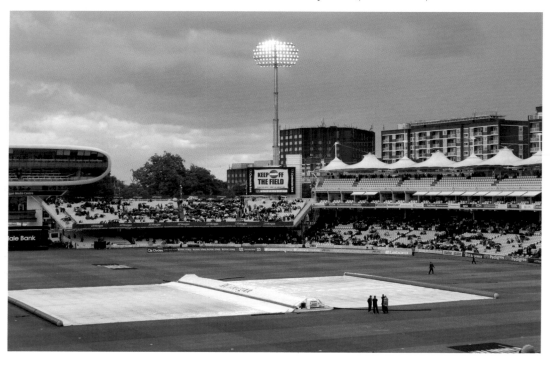

Nostalgia

Perhaps more than any other game, cricket luxuriates in nostalgia, and nowhere is the atmosphere more vibrant with it than Lord's. Joe Hardstaff's mistimed straight drive in the course of an otherwise sweetly timed 114 in the Lord's Test of 1937 is the stuff of nostalgia for those generations who admired the Nottinghamshire professional, both as a player and as a man.

Buildings too can induce nostalgia, even the least of them. The single-storey bar-cum-lavatories (below) may be the meanest of all Herbert Baker's buildings and, with some justice, cause a glint in any developer's eye, yet, despite the latest brand-imaging and Kevin Pietersen poster, it remains staunchly of the age of Hearne and Hendren and comfortably familiar to the ground's older supporters.

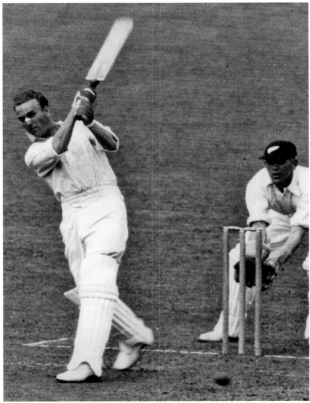

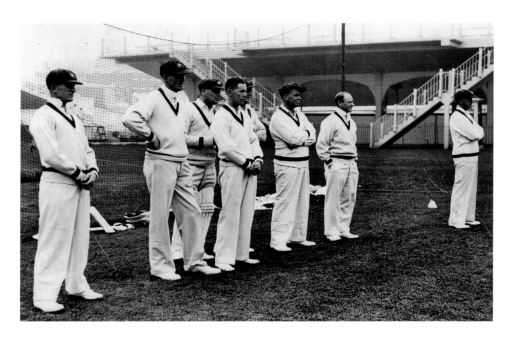

Changing Emphases

Above, with a background of Herbert Baker's 'free seating' at the Nursery End: some immaculately clad Australian tourists of 1934 studying an early season nets practice (left to right: Kippax, O'Reilly, Woodfull, Brown, Ponsford, Oldfield, Grimmett and Darling). Below, with a background of the Indoor Academy and Media Centre: the Brighton College girls' U15 team, runners-up in the National Finals of The Lady Taverners' U15 Indoor Schools Competition, 2009. One of the great joys of the contemporary scene is the increasingly high profile of women's cricket.

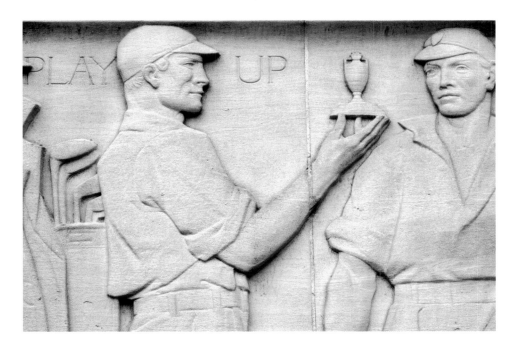

A Moral Code

'Play up, play up, and play the game' runs the Newbolt quotation along Gilbert Bayes' bas relief (showing cricketers with the Ashes between players of other games) installed outside the ground in 1934. Newbolt's suggestion that selflessness might be inculcated on the games field may not have modern resonance, yet it concurs with MCC's Spirit of Cricket campaign (as advertised, below) and Patsy Hendren's comment of 1926 that 'the Club have made cricket a name for all who love fairness and healthy rivalry'.

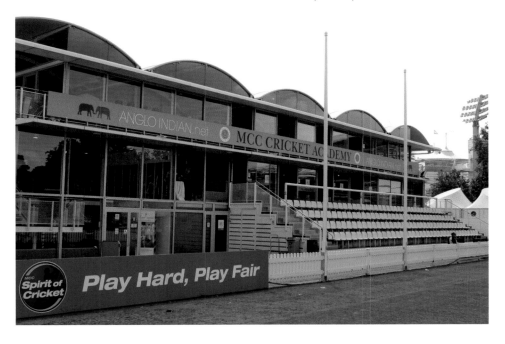

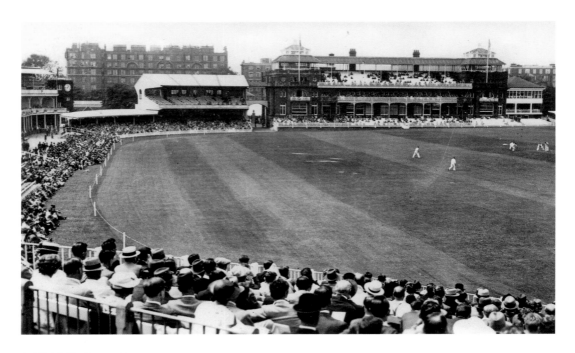

A Misfit Redeemed

In the mid-1930s Herbert Baker's new Q Stand looks a little gauche as it attempts the difficult task of nestling inconspicuously with the reassuring red brick of its late Victorian neighbours: the Tavern clock tower and the Pavilion. The coming of the new Tavern Stand in the 1960s similarly dwarfed it uncomfortably. But its recent new roof, with the acquisition of a massive electronic scoreboard, has given it more self-assertion and it no longer looks quite the same poor relation.

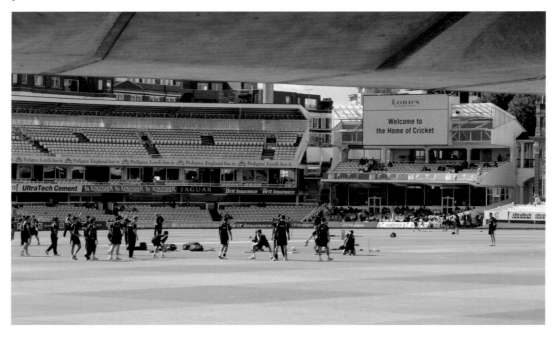

The Chic and the Comfortable

Britain might be struggling economically in 1935, the clouds of war gathering and the death of one king to be followed by the abdication of another, but some things, like the Eton-Harrow match, still brought out a defiant determination to defy the odds. Below, just inside the Grace Gates, at the back of the Tavern Stand, one of the popular tours of Lord's is in progress; and dress appropriate to the occasion is again the order of the day.

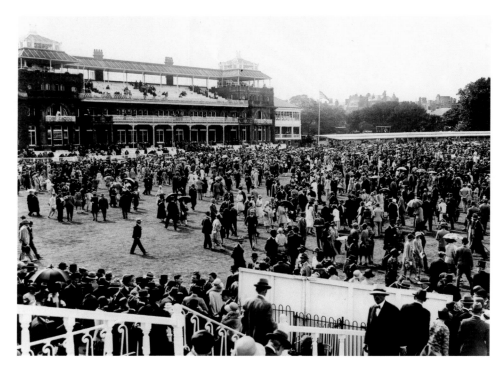

Interval Entertainment

Spectators at the Varsity Match of 1935, seen from the edge of the Mound Stand, traditionally fashioned their own entertainment in the intervals with leisurely perambulations. (The large gathering at the front of the pavilion would suggest that this particular one is motivated by the end of the match.) Below, though the modern Varsity Match is reduced from three days to one and no longer much of a draw, other big One Day occasions have all the fun of the fair.

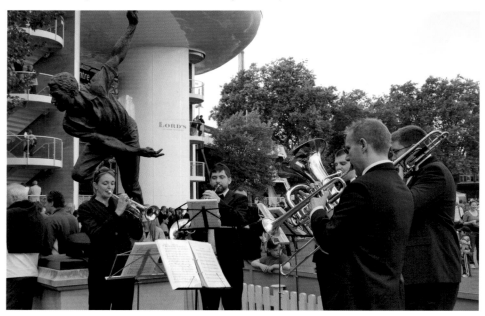

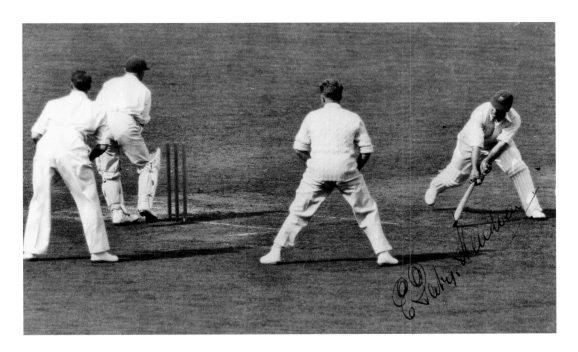

Dismissals

The thrilling finality of a batsman's dismissal is something few other sports can match. Above, in 1936 the forty-seven-year-old Patsy Hendren is stumped by Hampshire wicket-keeper Neil McCorkell for 9. He was still Middlesex's greatest run-scorer that season, though eighteen-year-old Denis Compton also made 1,000 runs. A year earlier Hendren had also been stumped by McCorkell, though that time for 100. Below, Somerset's Marcus Trescothick returns to the Pavilion, the camera and big screen heightening the moment of drama.

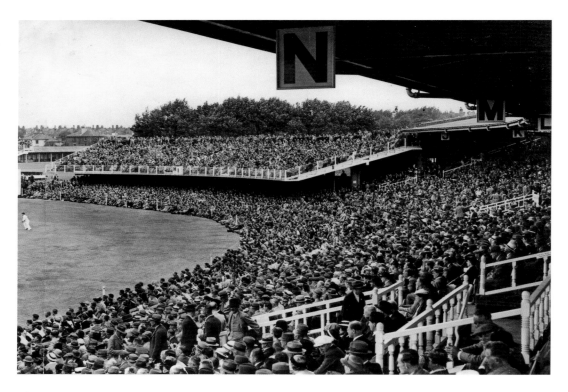

The Sincerest Form of Flattery

At first glance Blocks H/I of Herbert Baker's 'Free Seating' (above, as seen from the Mound Stand in the 1938 Test v Australia) and the Edrich Stand (below, in 2011) could be one and the same, though the modern stand offers greater headroom and the Spartan wooden benches are no more.

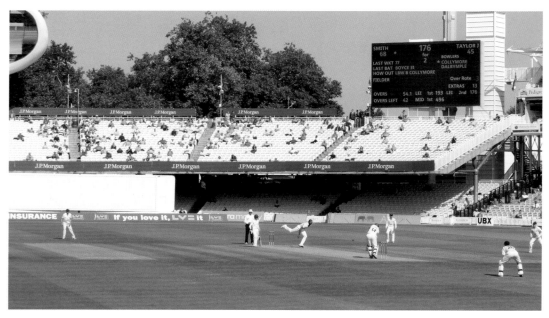

Admission to Stand (including Tax) 5/6

Block **L** No 838

LARGE MOUND STAND.

ENGLAND v. AUSTRALIA

SATURDAY, JUNE 23rd, 1934.

N.B.—This Ticket is to be retained by the holder as a voucher. It is numbered to correspond with the seat, and available only for the one indicated. It must be shown at all times when demanded, and especially on entering or re-entering the stand. On no day can cricket be guaranteed, and in no circumstances can money be returned.

ANY MISUSE OF THIS TICKET WILL ENTAIL ITS FORFEITURE.

This Ticket does not include admission to the Ground and is only available if accompanied by an Entrance Ticket.

Hidden History

The Saturday's play of the Second Test of 1934 would have been good value for the ticket holder, watching from Block L, the centre of the Mound Stand. For England reached 440 all out by mid-afternoon, with Leyland and Ames completing centuries, and though only two Australian wickets subsequently fell by the close (192–2), one of those was Bradman's. But there was greater drama yet in store. On the Sunday it rained, and on the Monday the great Yorkshire spinner, Hedley Verity, exploited the turning wicket (7–61 and 8–43) to bowl England to an innings victory.

Verity was subsequently among the many cricketers who perished in the Second World War and were later celebrated by a War Memorial Gallery, seen (below) from the Warner Stand. Its charmingly unobtrusive entrance at the back of the Pavilion gives little hint of the great riches of cricket history inside.

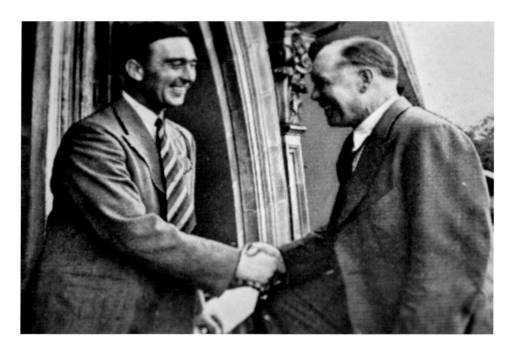

The Continuing Thread

Denis Compton, enjoying his golden season of 1947, is congratulated on the home balcony by Patsy Hendren, who coached at Harrow School and Sussex before becoming Middlesex's scorer in 1952. Below, the same balcony in modern times, the screen in the background alerting everyone to the ground's impressive green credentials. Compton and Hendren belonged to less anxious eras.

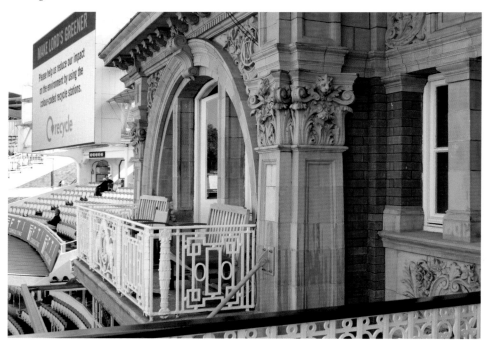

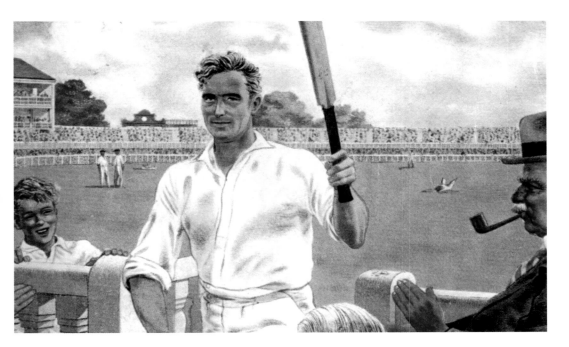

Family Skills

Above, Denis Compton, the ultimate *Boys' Own* hero, idealised in 1948. Below, Nick Compton, Denis's grandson, returning to the same pavilion, 2011. Nick, who made his television debut aged four when supporting his grandfather on *This Is Your Life*, first played for Middlesex in 2001, was capped in 2006 (when he scored 190 v Durham at Lord's) and moved four years later to Somerset, where, in 2011, he averaged 56 in championship matches and hit a big double century.

The Outside-Left

Though a right-handed batsman, Denis Compton was a left-armed bowler and left-footed soccer player. He and his elder brother Leslie (for many years Middlesex's wicket-keeper) were Arsenal stars in the early post-war years, Leslie as centre-half and Denis as a flamboyant, fast-running left-winger with a covetous eye for goal. Both won FA Cup winners' medals (1950) and international honours. Such footballing cricketers – and there were many of them – helpfully encouraged the bracketing of football and cricket as the country's major sports.

Below, Compton the cricketer fittingly honoured. It was the manner in which he approached the game which was so attractive. Batsmen at the time (before one-day cricket altered things) were correct and inhibited (rarely driving on the up). But Denis was the exception, the cheerful breaker of rules, the naughty schoolboy, forever impudently advancing down the wicket. In an age of conformity, he was loved for his impudence as much as his expertise. As E. W. Swanton put it, 'There was something boyishly daring about his batting even in his maturity, coupled with an endearing fallibility, whether in the matter of running between the wickets or turning up on time.' He was likewise cheeky as a bowler, breaking many a partnership with his inviting chinamen. He took 73 wickets in his vintage batting year of 1947.

He was lucky, of course, that he lived in an age where the media kept a respectful silence about sporting heroes' off-field antics. But the award of a CBE, instead of a knighthood, probably reflects his determination to enjoy himself at all times rather than his genius as a cricketer. And what did this small slight matter? He was Sir Denis in most people's hearts.

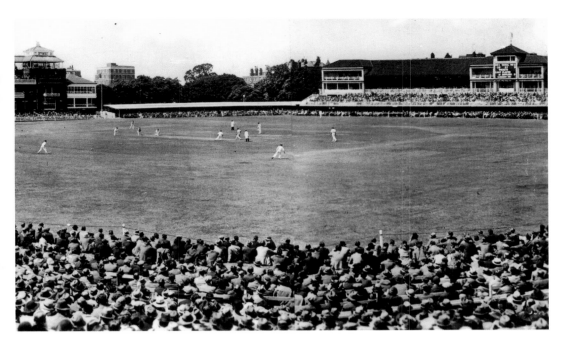

A Mixed Reception

Herbert Baker's Grand Stand, seen in 1953 during one of the most thrilling Tests of all, aroused mixed emotions, Kenneth Clark declaring that 'Baker had a positive genius for errors in design'. 43 per cent of seats within it were said to have restricted views, but it made a good backdrop for those watching the South Africans in 1994 and found a supporter in Viscount Chelmsford: 'Anybody who has been to Lord's can see how an architect of real distinction can invest a building of utilitarian purposes with dignity and beauty.'

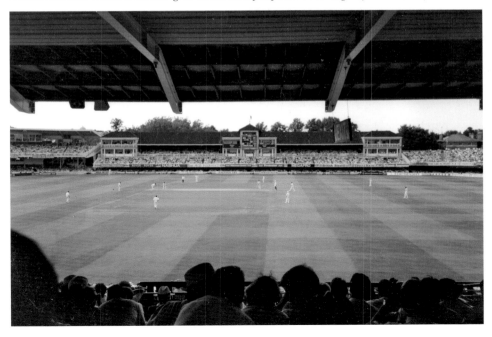

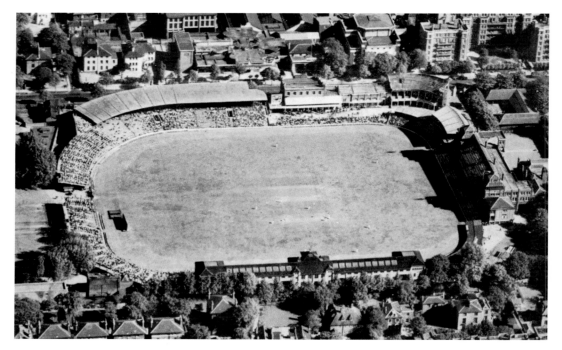

100th Test Match - Lord's Ground

WEST INDIES TOUR 2000

Alfred Valentine

$1

E-II-R

MONTSERRAT

A Reality Check

Post-war austerity meant that by 1950 Lord's was a Sleeping Beauty, its buildings partly reflecting the era of W. G. Grace and partly those of the Jazz Age. It was enjoying a deep slumber, too, in its patriarchal attitudes to other countries. With the exception of the Australians (rather a special case with their Trumpers and Bradmans), England expected to beat all comers, so it was a terrible shock in 1950 when the twenty-year-old West Indian spinners Sonny Ramadhin and Alf Valentine proved unplayable and the trouncing of Norman Yardley's England was celebrated by cheerful Caribbean calypsos. 'Cricket, lovely cricket', sung on the sacred Lord's turf, signalled a new beginning to the second half of the century: an era of high-profile international battles, in which Pakistan and Sri Lanka led the introduction of new blood, and Lord's became the symbol of old empire where every invader particularly wanted to hoist the flag of victory.

Never Never Land?

Lawson For Lord's, published in 1950, is a long-forgotten book for younger readers: 'It was a thrill for the boys of Cavalier's School, when they heard that one of them, Lawson, was to play for MCC at Lord's. And it was an even greater thrill for everyone concerned when Lawson disappeared on the very eve of the Test Match. Had he been kidnapped – and, if so, why? Would he play in the Test Match after all?' Gently naïve though the storyline is, there's a clear-cut message about good triumphing over evil, and selflessness over self-interest, which transcends the privileged background, reflects the Bayes bas relief (also illustrated on page 75), and raises issues about the Spirit of Cricket. Was Lawson's Lord's, in fact, a never never land? Or is MCC's campaign on the Spirit of Cricket one of the most important items on its agenda?

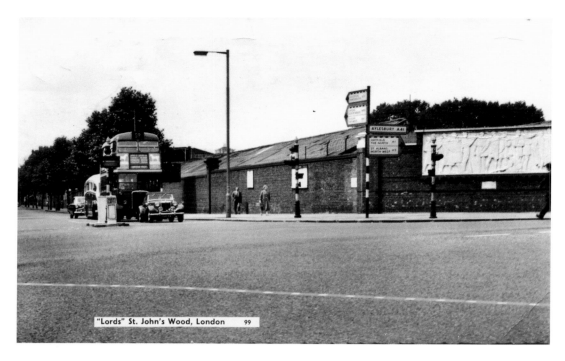

"Lords" St. John's Wood, London 99

Relief at the Junction

Above, the junction of Wellington and St John's Wood Roads around 1950, with the Bayes bas relief on the right. Below, the Cricket Academy dominates the modern view, while dense traffic often obscures the relief (now surrounded by see-through railings) and lessens its attractions.

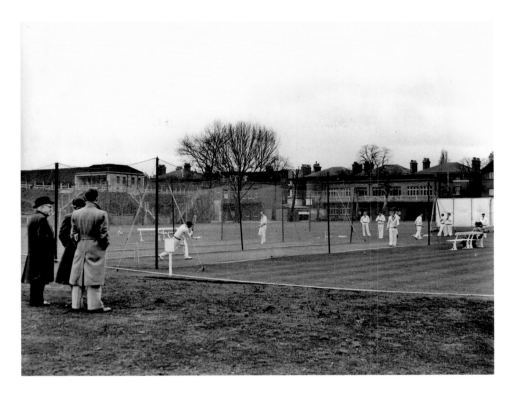

Spring and Summer

Above, on a cold day in mid-April 1953, the Australian tourists begin the defence of the Ashes with their first nets on the Nursery Ground; behind them the workshop buildings of the 1920s. Baker's Grand Stand and 'free seating' are dimly visible to the left. Below, the same view, but in summer mode, six decades later.

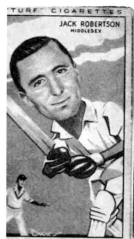

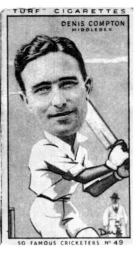

"TURF" CIGARETTES — JACK ROBERTSON MIDDLESEX — 50 FAMOUS CRICKETERS Nº 17

"TURF" CIGARETTES — SYDNEY BROWN MIDDLESEX — 50 FAMOUS CRICKETERS Nº 26

"TURF" CIGARETTES — BILL EDRICH MIDDLESEX — 50 FAMOUS CRICKETERS Nº 50

"TURF" CIGARETTES — DENIS COMPTON MIDDLESEX — 50 FAMOUS CRICKETERS Nº 49

Middlesex Stars

In the late 1940s and early 1950s, fathers all over the land had to change their brand of cigarette to Turf to appease their children, desperate to have a strong swop collection of the latest Turf sports stars. All four members of Middlesex's prolific top order were highly popular (but often somewhat creased) swops. Below, at the top of the Middlesex order sixty years later, Andrew Strauss resumes an innings against Leicestershire, eventually making a career-best 241*. Comparisons between cricketers of different eras are difficult, given the much heavier demands made today. Strauss's batting averages, for example, are split by statisticians into no less than 6 categories: Tests; One-day internationals; First-class domestic cricket; List A; and both domestic and international Twenty20. Middlesex's top four of 1950 could qualify for only two of these categories.

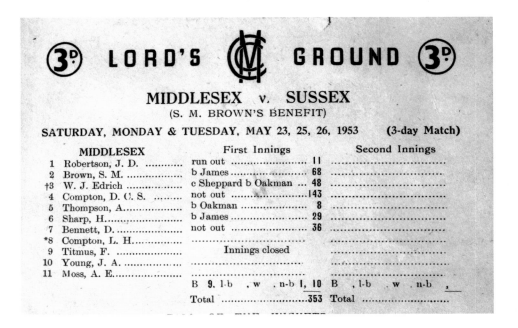

③ᴰ LORD'S Ⓜ GROUND ③ᴰ

MIDDLESEX v. SUSSEX
(S. M. BROWN'S BENEFIT)

SATURDAY, MONDAY & TUESDAY, MAY 23, 25, 26, 1953 (3-day Match)

	MIDDLESEX	First Innings	Second Innings
1	Robertson, J. D.	run out ... 11	
2	Brown, S. M.	b James ... 68	
†3	W. J. Edrich	c Sheppard b Oakman ... 48	
4	Compton, D. C. S.	not out ... 143	
5	Thompson, A.	b Oakman ... 8	
6	Sharp, H.	b James ... 29	
7	Bennett, D.	not out ... 36	
*8	Compton, L. H.		
9	Titmus, F.	Innings closed	
10	Young, J. A.		
11	Moss, A. E.		
		B 9, l-b , w , n-b 1, 10	B , l-b , w , n-b ,
		Total ... 353	Total ...

The Scorecard

Despite poor attendances at today's county championship and its consequent removal from a central position in the season, there have still been both scorecards and match programmes available at Lord's, a gesture of support much appreciated by those who relish the subtleties of the game's longer format. Upgrading of county scorecards may well be a thing of the past (as suggested below), but if the after-tea sessions were ever imaginatively presented as separate entities to those seeking entertainment after work, a well-presented overview of the current state of play would be one essential.

An August Name

One of Warner's biographers thought that the bust in the stand named after him 'stared you out of countenance' and he detected 'a touch of minatory ferocity foreign to the essential gentleness of his temperament'. The stand (seating nearly 3,000) was the mid-1950s answer to a thirty-year waiting list for prospective MCC members. It was an old idea which had long been delayed because it involved demolishing Block A, 'the stronghold of the most elite socialites of their day'. The choice of the august Warner as its dedicatee probably helped soften resistance, and eventually, in 1958, Plum himself opened the new stand. Five years later, after his death at the age of eighty-nine, his ashes were scattered on the grass in front of it.

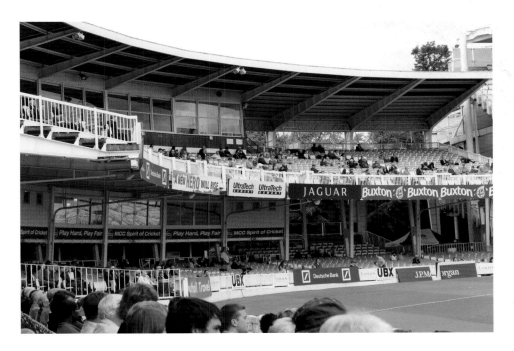

Media Movement

At the back of the upper level of the Warner Stand a sound-proofed Press Box gave new accommodation to nearly 100 newspaper reporters as well as BBC radio and television commentators (who were vacating a somewhat better view, behind the bowler's arm, on top of the Pavilion). The arrival of the Media Centre in 1999, however, not only restored these key observers to an infinitely more helpful position, but doubled the number of possible journalists and created eleven radio and television commentary boxes.

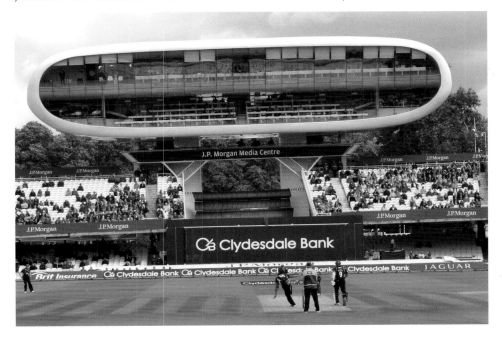

Glum Looks

For a ground which has so much charm and good architecture, the route between the Grace Gates and the Pavilion is something of a visual disappointment, which might partly account for the somewhat glum expressions of those with the Duke of Windsor, visiting in the early 1960s for the first time since his abdication. Flower boxes and bold sign-writing struggle to counter the prosaic 1960s feel of the Tavern Banquetting Suite.

New Horizons

In the early 1960s Lord's began to host the Finals of the first one-day Trophy, the Gillette Cup, won for the first two years by Sussex, whose captain, Ted Dexter, is seen (above) celebrating his county's double in 1964. Smiling quietly behind him is MCC's officiating President, Gubby Allen. The rowdier aspects of the one-day game would hardly have appealed to him, but Allen recognised as well as anyone the new lease of life it offered the sport. Though both a successful stockbroker and golfer in his later years, Allen remained unswerving in his service to MCC and Lord's, keeping in neat chronological piles every agenda and all the minutes of the countless meetings he attended. Below, the still verdant view from the Pavilion, which Allen in his lifetime fought hard to protect. He never saw the futuristic Media Centre which obscures a certain number of the trees ...

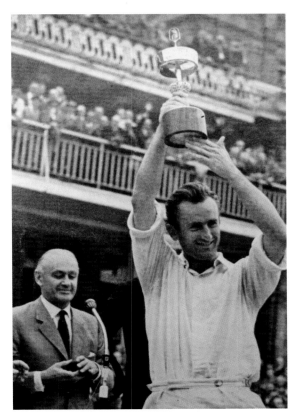

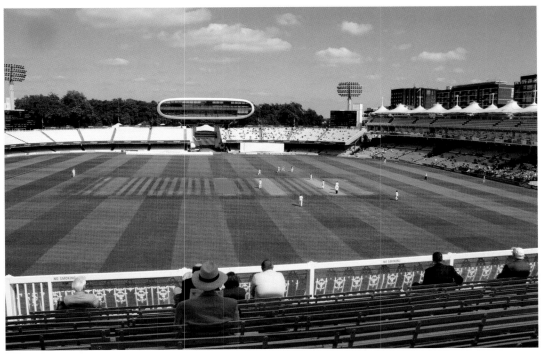

The Spirit of Lord's
Denis Compton in the early 1990s with Brian Johnston, one of the game's best-loved commentators, now commemorated by a Brian Johnston Film Theatre in the MCC Museum.

Acknowledgements

Grateful thanks to Marylebone Cricket Club and Middlesex County Cricket Club, together with Chris and Philippa Atkinson, Westie Boycott, David Ellsmore-Petty, the Provost and Fellows of Eton College, Richard Green, Col. Duncan Hyslop, Michael Meredith, Heather and Jo Meredith, Neil Robinson, Clare Skinner and Charlotte Villiers. Cricket historians will always be indebted to Sir Pelham Warner's *Lord's 1787–1945* (Harrap, 1946) and Diana Rait Kerr and Ian Peebles' *Lord's 1946–70* (Harrap 1971). The ground has also been particularly well served by Stephen Green's charming *Lord's, the Cathedral of Cricket* (Tempus, 2003), Jonathan Rice's helpful *One Hundred Lord's Tests* (Methuen, 2001) and, last but by no means least, that beautifully presented architectural history, *Pavilions of Splendour* (Methuen, 2004), edited by Duff Hart-Davis.